W9-CFT-258

Discover Art

Laura H. Chapman

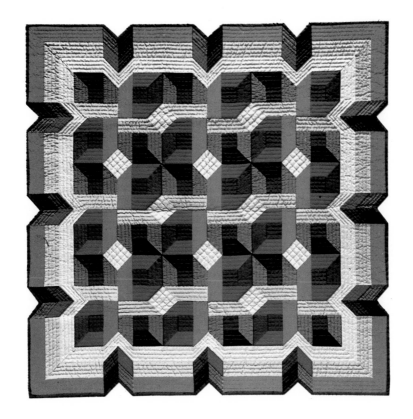

Grade 6

Davis Publications, Inc.

Worcester, Massachusetts

Title page: Peggy Spaeth, *Box Quilt.*
Courtesy The Canton Art Institute,
Ohio.

Printed in the United States of America
ISBN: 0-87192-158-8
SE 6

Twelfth Printing, 1992

2

Acknowledgements: The author wishes to
acknowledge with gratitude the
contributions of principals, teachers and
students who participated in the field test,
the editorial and design staff of Davis
Publications, and the following individuals:
Gerald F. Brommer, author and artist, Los
Angeles; Nancy Denney, art teacher,
Brantner Elementary School, West
Clermont, Ohio; Joseph A. Gatto, Los
Angeles Public Schools; Carol Hartsock,
fiber artist; George F. Horn, formerly
Coordinator of Art, Baltimore Public
Schools; Barbara Marks, art teacher, Paxton
(Massachusetts) Center School; Gini
Mercurio, interior designer and editorial
assistant, Cincinnati, Ohio; Patricia A.
Renick, University of Cincinnati; Jerry
Samuelson, California State University at
Fullerton; Jack Selleck, Los Angeles Public
Schools; and Jack Stoops, formerly of
University of Washington and University of
California, Los Angeles.

Publisher's Note: The Publisher is indebted
to the author for her conceptualization and
for keen insight into the selection of the
visual materials for this series.

Managing Editor: Wyatt Wade
Production Editor: Margaret M. McCandless
Photo Acquisition and Editorial Assistance:
Laura J. Marshall
Claire Mowbray Golding
Graphic Design: Gary Fujiwara
Cover Design: Author
Illustrator: Joan Cunningham

Contents

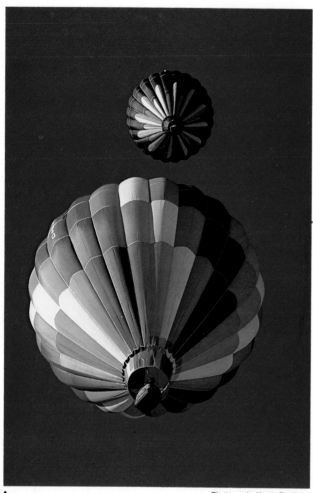

A Photograph: Karen Durlach.

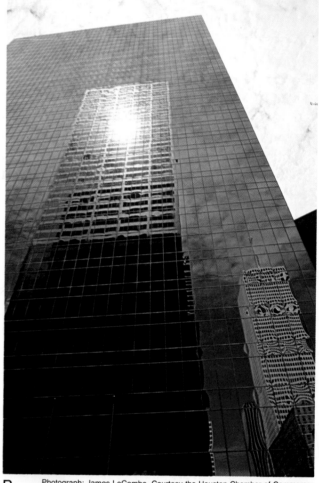

B Photograph: James LaCombe. Courtesy the Houston Chamber of Commerce.

Open your eyes! The world of art begins with things you see and remember. What is the most colorful thing you have seen today? What shape was it? Was it near or far away? Was it rough or smooth?

Look at the hot air balloons in picture A. Try to describe everything you see.

Think about things you see. Thinking can help you in art, just as it can help you in other subjects. In art, questions often have more than one correct answer. See if you can answer these questions.

In picture A, why does the top balloon look so small?

In picture B, why does the top of the skyscraper look so narrow?

Use your imagination. Artists learn to use their imagination. Look at the shapes of clouds reflected on the skyscraper in picture B. Do some of the shapes look like strange insects, faces or landscapes?

Imagination is important in many kinds of art. Marc Chagall, a French artist, created the painting shown in picture C. Parts of the painting look almost real. Parts look unreal, like a dream. Many artists combine real and unreal things to create imaginative art.

C Marc Chagall, *I and the Village*, 1911. Oil on canvas, 6'3 5/8 × 59 5/8" (192 × 151 cm). Collection, The Museum of Modern Art, New York (Mrs. Simon Guggenheim Fund).

Imagination is important in many kinds of art. An artist created this advertisement. What parts of the artwork look almost real? What parts look unreal?

Show what you have learned. Use your imagination. Think of a new or unusual way you could travel to and from school. Create a drawing of this new form of transportation.

Courtesy 7-Up Company, St. Louis.

D

Drawing
Ideas For Pictures

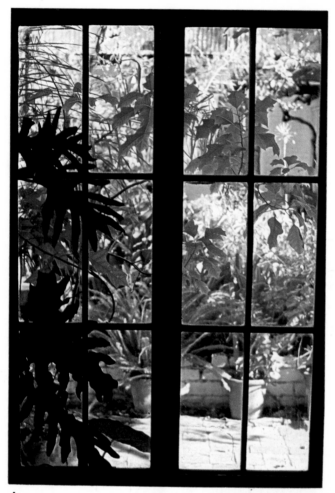

A

Some artists like to draw or paint imaginary scenes. Others like to draw scenes they see. Sometimes **part** of a scene is more interesting than the **whole** scene. Artists look for parts of a scene that they want to draw.

This photograph shows a garden scene outside a large window. You can see parts of the scene through each small window. An artist might draw the whole scene or part of it.

Look at pictures B, C and D. Do you see how artists might choose parts of a scene to draw?

D

B

C

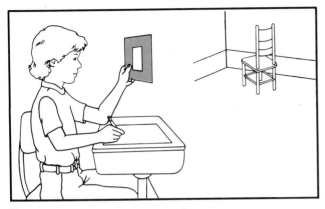

E

Use a **viewfinder** to choose a scene. A viewfinder is a sheet of paper with a hole in it. Draw what you see through the hole. Draw it very large.

Picture F shows two views of the same chair. Which view looks best to you? Why? Do you see how artists choose the shapes of their artwork?

F

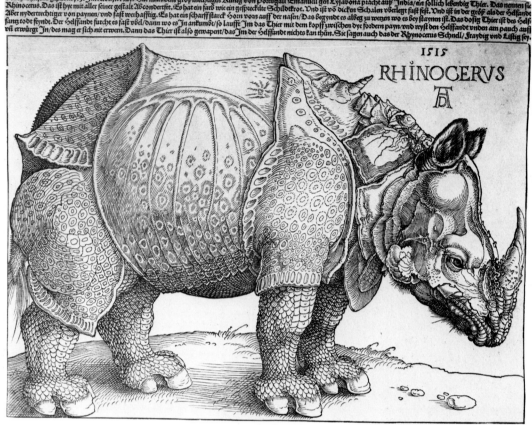

A

Albrecht Dürer, *Rhinoceros*, 1515. Woodcut. Print Collection, The New York Public Library (Astor, Lenox and Tilden Foundations).

Artists create many kinds of **lines.** They use lines to create shapes, textures and patterns. They can use lines to express ideas and feelings, too.

Albrecht Dürer outlined the main **shapes** of the rhinoceros in this artwork. The very small lines and shapes suggest the **texture** of the hide. Some of the shapes are repeated to make **patterns.**

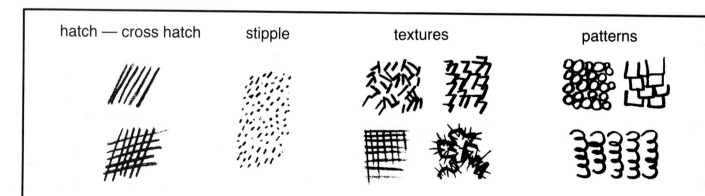

hatch — cross hatch stipple textures patterns

D Can you create and use lines in many ways?

10

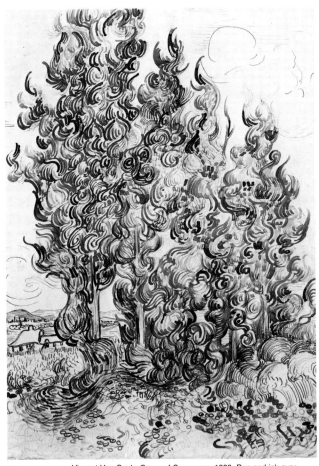

B Vincent Van Gogh, *Grove of Cypresses*, 1889. Pen and ink over pencil, 24 × 18″ (626 × 465 mm). The Art Institute of Chicago, Illinois (Gift of Robert Allerton).

A feeling of motion and energy is an important part of this drawing by Vincent Van Gogh. He used curved and swirling lines to capture this feeling. What other lines did the artist create?

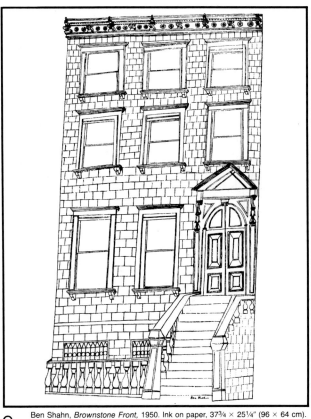

C Ben Shahn, *Brownstone Front*, 1950. Ink on paper, 37¾ × 25¼″ (96 × 64 cm). Hood Museum of Art, Dartmouth College, Hanover, New Hampshire (Purchase from the Whittier Fund).

Ben Shahn's drawing helps you see how the building is constructed. Can you describe the kinds of lines he used?

Try to improve the drawing you created during the last lesson. Add lines or change lines to express an idea or feeling. Would outlines, textures or patterns improve your drawing?

delicate curves bold angles smooth — jagged light to dark thick to thin

Drawing
Shapes and Structures

Artists practice drawing in many different ways. Sometimes they begin a drawing with the main shapes they see. What is the main shape of the tree in this etching? The etching was created by Hercules Segers.

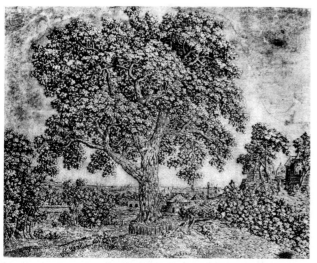

A

Hercules Segers, *The Large Tree.* Etching, printed in black, 8⅝ × 10⅞″ (22 × 28 cm). Rijksmuseum, Amsterdam.

Practice drawing some trees. Draw the main shapes first, as some artists do.

1. Draw the main shape first.

2. Draw shapes that go inside or outside the main shape.

3. Draw the edges of the most important smaller shapes.

4. Add details such as patterns, textures or shadows.

B

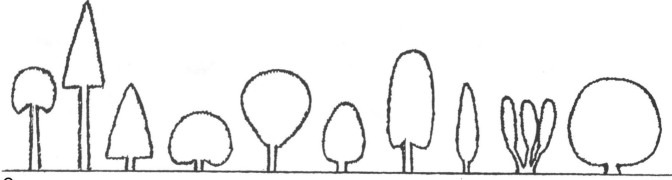

C

Here is another way to practice drawing. You can begin with the structure (the main lines or "skeleton") of things you see.

Most trees have a definite shape and structure. The veins in leaves also have a definite shape and structure. Practice drawing the shape and structure of trees and other things you see.

1. Draw the main structure first.

2. Draw parts that branch out from the main structure.

3. Draw parts that are joined to the main structure.

4. Add details such as patterns, textures or shadows.

D

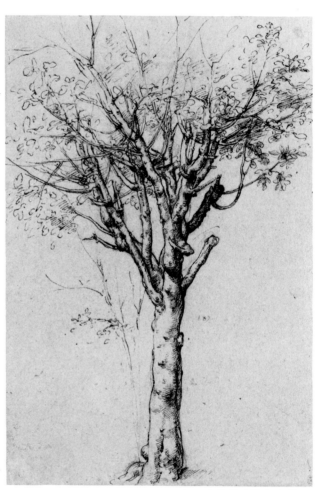

E

Leonardo Da Vinci, *Study of a Tree*.
The Royal Library, Windsor, England.

F

Drawing
Value, Shading, Contrast

A B

The term **value** is used in art to describe the lightness or darkness of lines, shapes and colors. Artists can use many values, such as those in picture A. Some artists prefer to use only a few values, such as those in picture B.

Emily Carr, a Canadian artist, used many values in this drawing. Look at parts of her drawing through the binder hole in a sheet of notebook paper. Can you find at least five values?

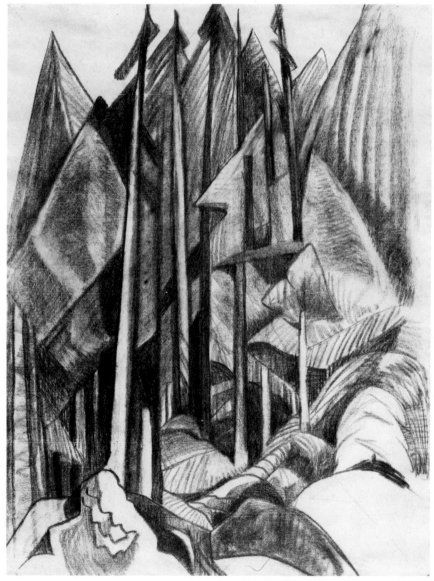

C

Emily Carr, *Nootka*. Charcoal, 24 × 19″ (62 × 48 cm). Vancouver Art Gallery, British Columbia.

Artists use values in various ways.

The artist has shaded objects in picture D to make them look three-dimensional (not flat). **Shading** is a very gradual change from light to dark values. Where do you see shading in this drawing?

D

This drawing has very dark values next to very light values. This big difference in values is called **contrast.** Look for places in the drawing where contrast has been added. Do the objects still look three-dimensional?

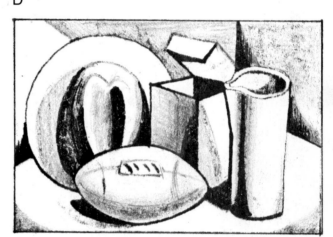

E

The artist has invented some shapes and colored them with different values. This makes the artwork more like a flat design. The objects do not look three-dimensional.

Add values to the drawing you made in the last lesson. You can use shading and contrasts to make objects look three-dimensional.

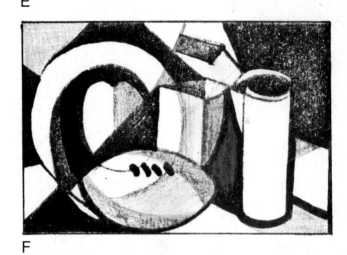

F

If you prefer, make your drawing look like a flat design with many different values.

Drawing
Variations on a Theme

Artists learn to be **creative.** A creative artist thinks of many ways to make art. Creative artists learn to invent many variations on an idea or **theme.**

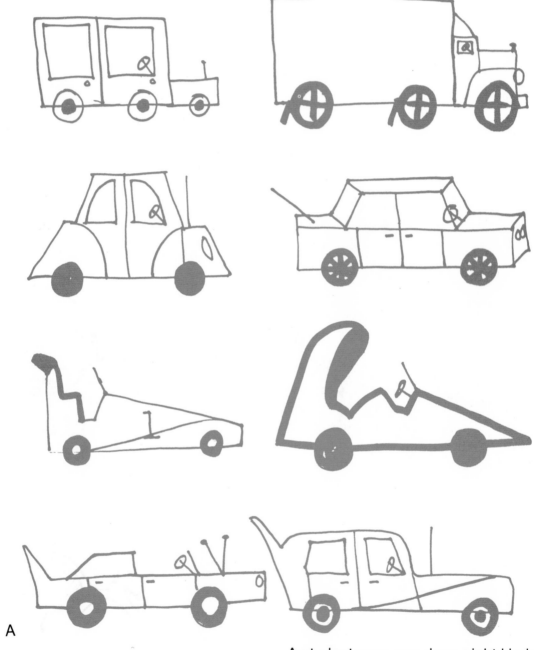

A

A student your age drew eight kinds of automobiles on one page. She changed the lines, shapes and details in each car. She invented eight variations on the idea of automobiles.

In art, a **variation** is a change or difference in the lines, shapes or colors you use. What variations do you see in the six pairs of eyeglasses drawn by a student?

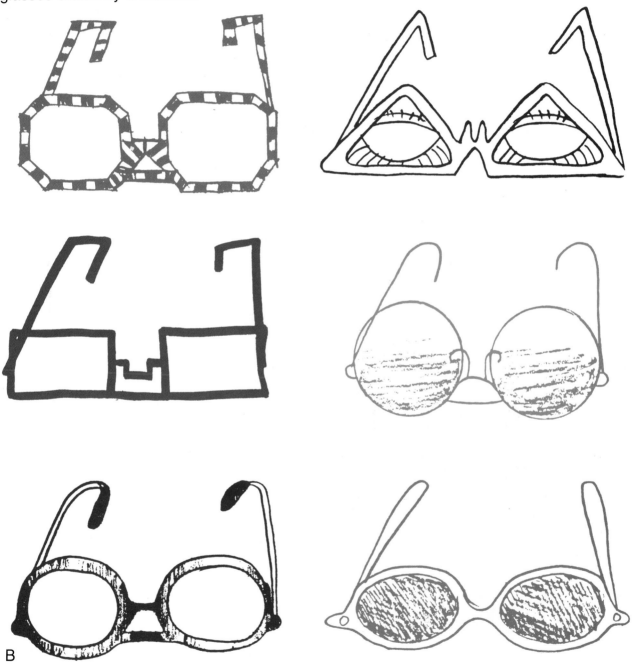

B

You can learn to be creative. Think of an idea or find an object to draw. Make a page full of drawings. Invent variations that make each drawing different from the others.

17

7

Color
Colorful Mosaics

Artists learn to see very small differences in colors. They learn to mix many colors using crayons, chalks or paints.

Try this color-mixing experiment with crayons. It will help you see and create many colors.

A

1. Make six stripes of different colors. Make each stripe about the same width.

B

2. Use the same six colors to add six stripes across the first ones. Your paper should look like this, with thirty-six colors.

3. Now cut your paper so that each color is separate. You will use your colors to create a paper mosaic.

C

Mosaics are pictures or designs made from small pieces of colored glass, stones or other materials. You can use paper. The pieces are glued down side by side. In glass or stone mosaics, the spaces between the pieces are filled in with plaster.

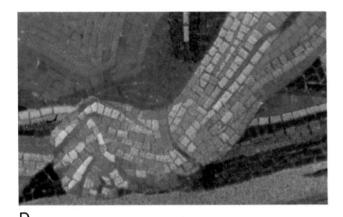

D

Small patches of color can seem to blend when they are placed side by side. How does this happen in moasics?

Pictures C, D and E are details from mosaic murals created by Winold Reiss for a railroad station in Cincinnati, Ohio. The murals were completed in 1933.

The mosaic in picture F is more than 1700 years old. It was found in Antioch, a city in Syria.

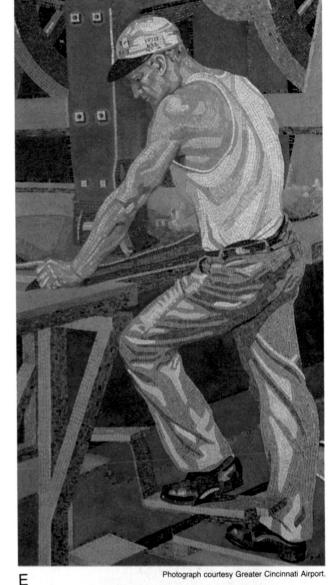

E

Photograph courtesy Greater Cincinnati Airport.

Create a small paper mosaic from the pieces of paper you have colored. Cut or tear your paper into smaller pieces. Paste the pieces down side by side, like puzzle pieces. You might use one of your drawings from the last lesson for your design.

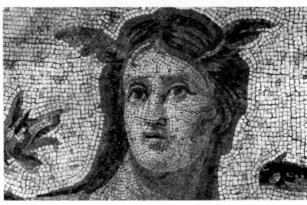

F

Thalassa, Goddess of the Sea, Mosaic, Antioch, 3rd century A.D. 6′4″ × 4′6″ (193 × 137 cm). The Baltimore Museum of Art, Maryland (The Antioch Project Fund).

Colors
Pure, Warm, Cool, Neutral

Color Wheel

yellow

green

orange

Warm
Colors

Cool
Colors

blue

red

violet

A

This color wheel shows six pure colors. A **pure** color is similar to the bright, intense colors you can see in a rainbow.

Rainbow colors are seen when sunlight shines through raindrops. You can also see pure colors when light shines through a prism.

Red, yellow and orange are often called **warm** colors. They remind people of warm feelings or warm things such as the sun or fire.

Blue, green and violet are often called **cool** colors. They remind people of cool feelings or cool things such as water or ice.

There are many other groups or families of colors.

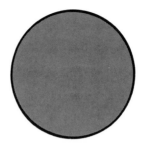

B

Brown, black, gray and white are not colors that you see in a rainbow or prism. Artists call these four colors **neutral** colors.

A neutral color can be changed by adding warm or cool colors to it. Perhaps you have heard of a "warm brown" or a "cool gray."

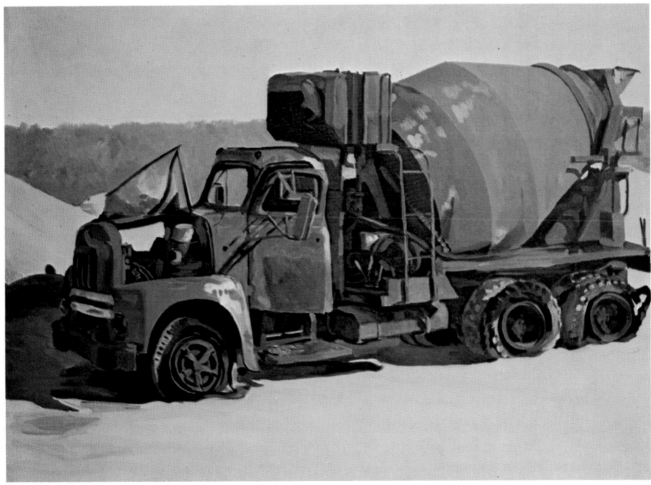

George Nick, *Burnt-Out Cement Truck*, 1977. Oil on canvas, 36 × 48″ (91 × 122 cm). Courtesy of the artist.

C

This painting by George Nick has many neutral colors. Can you point to some neutral colors that look warm? Do you see some neutral colors that look cool?

Look around your classroom. Where do you see neutral colors? Create a drawing with many neutral colors. Make some of the neutral colors look warm or cool.

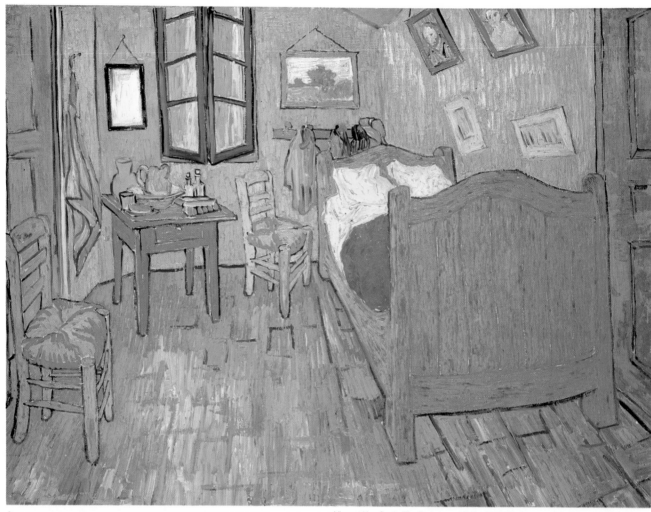

A

Vincent Van Gogh, *The Bedroom at Arles,* 1888-89. Oil on canvas, 29 × 36″ (74 × 91 cm). The Art Institute of Chicago, Illinois (Helen Birch Bartlett Memorial Collection).

Vincent Van Gogh created these two paintings of his bedroom. His paintings show how light can change the color and mood of a room.

Van Gogh's real bedroom had a reddish-brown floor and lilac-colored walls. The artist changed these colors in his paintings. Each painting shows the same room with a different light.

Changes in light and color can make a difference in how we feel. Your room looks and feels one way on a clear day and a different way on a cloudy day. Each of Van Gogh's paintings has a special mood, too.

Look at the cool colors in this painting. Find the green color on the reddish-brown floor.

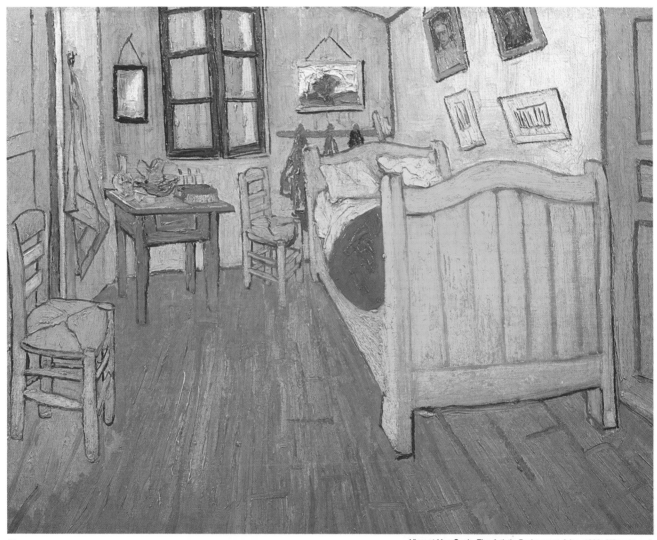

B

Vincent Van Gogh, *The Artist's Bedroom at Arles*, 1889. (72 × 91 cm). Stedelijk Museum, Amsterdam.

Notice the warm colors in this painting. The reddish-brown floor is shown with a golden light.

Create a colored drawing of your classroom. Express a mood using warm or cool colors.

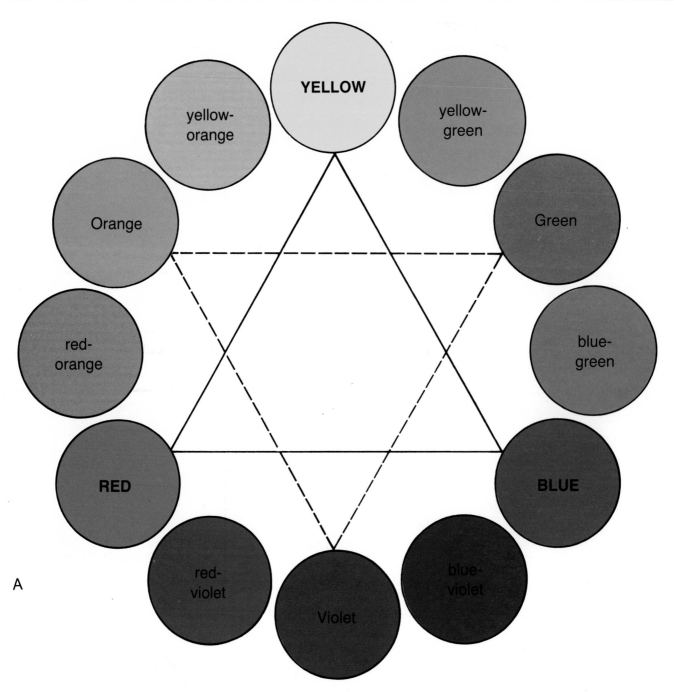

A

This color wheel will help you remember important ideas about mixing colors.

1. **Primary** colors are red, yellow and blue. You can mix other colors from them.

2. **Secondary** colors are orange, green and violet. These colors are created by mixing two primary colors.

3. **Intermediate** colors are yellow-orange, yellow-green, red-violet, red-orange, blue-violet and blue-green. All these can be mixed from primary colors.

4. Related colors are next to each other on the color wheel, such as blue, blue-violet and violet.

Practice mixing paints to create secondary and intermediate colors. Use three sheets of paper.

Begin each sheet with four circles of paint. Add dots of color to the painted circles as shown.

B

When your first sheet is ready, brush the "dots" of paint so the two colors blend together.

Complete your next two sheets in the same way. Your practice sheets will look similar to these.

C

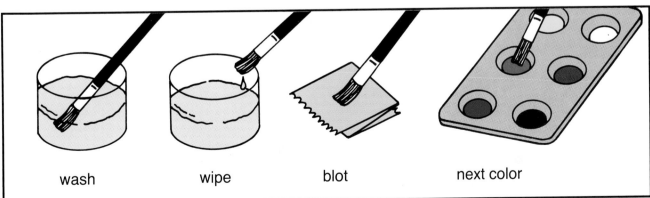

wash wipe blot next color

D Use your tempera paints this way. Do you know why?

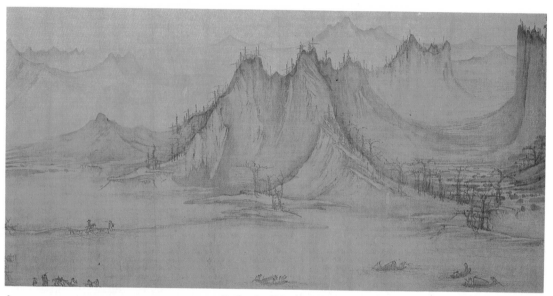

A

Hsu Tao-ning, *Fishermen*, Handscroll, ink and slight color on silk, 19 × 82″ (49 × 210 cm). The Nelson-Atkins Museum of Art, Kansas City, Missouri (Nelson Fund).

Art from China, Japan and other parts of Asia is called oriental art. Pictures A, B, C and D show oriental scroll paintings on silk cloth. A **scroll painting** is a very long painting that can be rolled up.

In many oriental cultures, a love of nature is very important. Artists try to create art that helps people see nature in many ways. Sometimes artists use a brush to write poems on their paintings. The beautiful handwriting is called **calligraphy.**

Paintings on silk are usually done with a brush and watery, transparent ink or paint. **Transparent** means you can see the silk under the paint. Thick paints are more opaque. **Opaque** paints cover up a surface.

Today you will use watery tempera paint or special paints called **watercolors.** Try to make a very delicate or unusual painting of something you have seen in nature.

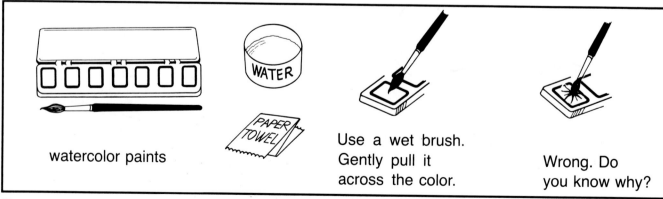

watercolor paints

WATER

PAPER TOWEL

Use a wet brush. Gently pull it across the color.

Wrong. Do you know why?

E

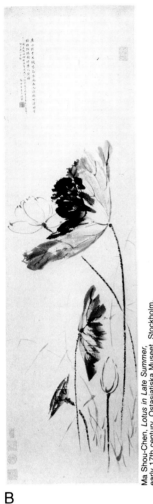

B

C

D

Ma Shou-Chen, *Lotus in Late Summer,* early 17th century. Ostasiatiska Museet, Stockholm.

Tzu-Hsi, *Peonies and Cat Meowing at Pug Dog,* late 19th century. Field Museum of Natural History, Chicago, Illinois.

Hokusai, *Ducks in a Stream.* British Museum, London.

You can let some of your colors run together. The soft fuzzy edges can be beautiful. Plan your brushstrokes so the paper is not completely covered.

Paint on dry paper

Paint on wet paper

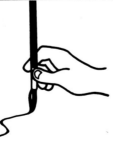

Use the tip
for a thin line.

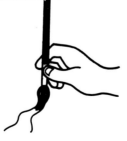

Press down
for a wide line.

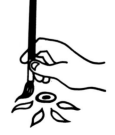

Make small shapes
with one stroke.

Artists in many lands have created pictures of imaginary animals. Some of the creatures are important in the myths and legends of people.

Study these examples. Think of an imaginary animal and draw it. Your creature could be beautiful or ugly. It could be gentle or mean. You might combine parts from birds, fish, insects or other animals that you like or dislike. Use your imagination!

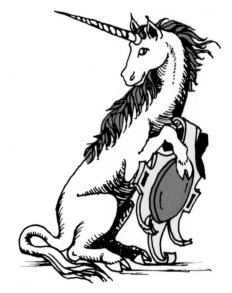

B

A **unicorn** is a wild animal that may be tamed by gentle people. Unicorns were part of Roman myths and legends from the Middle Ages.

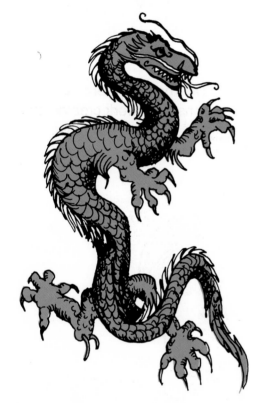

A

Chiao is a dragon of good fortune. The Chinese and Japanese have many legends and myths about dragons.

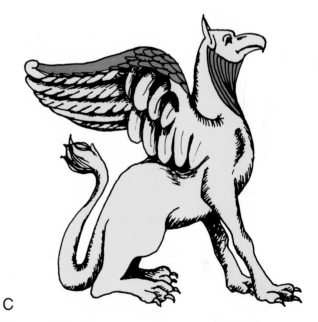

C

The **griffin** is a creature in Greek myths that built nests from gold and protected treasures. The griffin is part lion, part eagle.

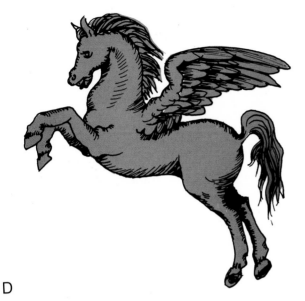

D

Pegasus is a flying horse. In Greek myths, Pegasus helped a young warrior fly through the air and slay a fire-breathing dragon.

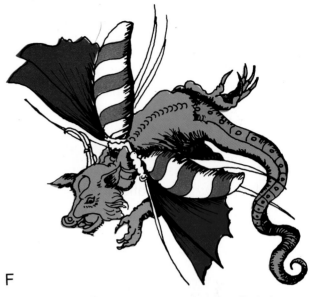

F

This **Flying Demon** represents evil. It is one of many demons in artwork created by Lucas Cranach the elder, a German artist.

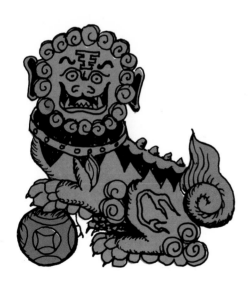

E

Fu is an imaginary dog of China. He will guard a home with great energy and valor.

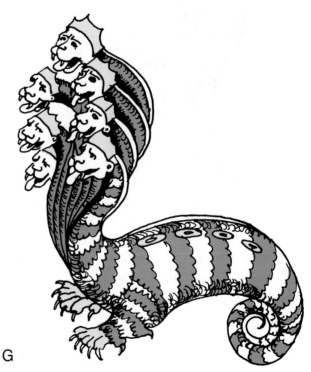

G

The **hydra** is a monster in Greek myths. It grew two heads when one was cut off. The hydra was slain by Hercules.

Relief Sculpture
Art of the Cave Dwellers

Some of the oldest paintings in the world have been discovered in caves. Scientists believe some of the paintings are more than 25,000 years old. The paintings were made by people who lived in caves. They hunted wild animals for food.

This photograph shows part of a cave painting found in France. Some art experts believe the cave people painted animals to bring them good luck before they went hunting.

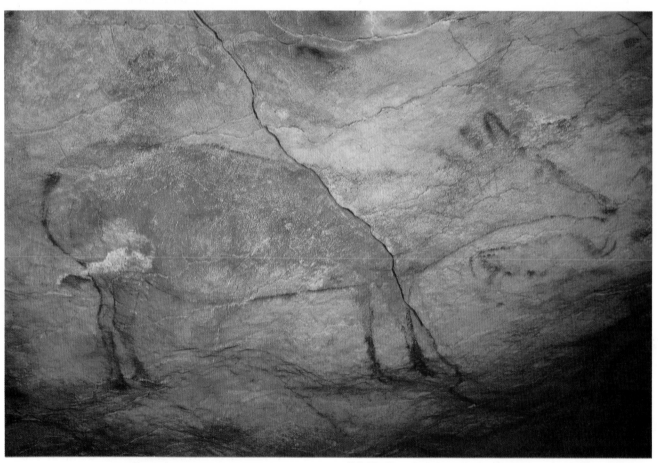

A

Hall of the Bison, detail of stag, Altamira. Photograph courtesy Art Resource, New York.

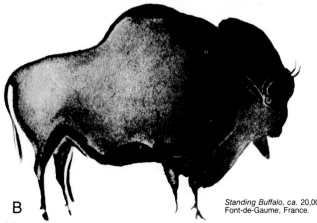

Cave artists did not have paints, brushes or other art supplies like ours. What could they use to make paint? What could they use for a brush?

B

Standing Buffalo, ca. 20,000 B.C. Cave painting. Font-de-Gaume, France.

This carving was made more than 12,000 years ago. The sculpture was carved in a piece of a reindeer's antler. The sculpture shows a bison licking its back. The cave dwellers carefully observed animals. Can you explain why?

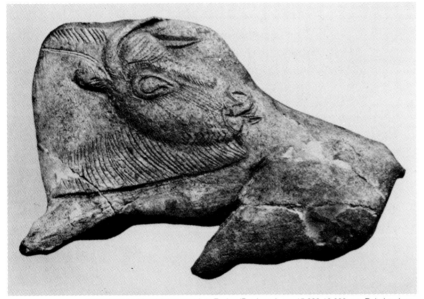

C

Bison from La Magdeleine near Les Eyzies (Dordogne), *ca.* 15,000-10,000 B.C. Reindeer horn. Museum of National Antiquities, St.-Germain-en-Laye, France.

In this lesson and the next, you will practice relief carving. Carve a fish, bird, insect or animal from a flat clay slab. Use the point of a paper clip to carve an outline in the clay.

Use the round end of the paper clip to subtract clay from the background. This will make your animal a relief sculpture. A **relief sculpture** is raised above a background. Try to carve some textures and other details, too.

D

E

The people of ancient Egypt created many kinds of art. The examples of sculpture shown here were created by artists who worked for the rulers, or pharaohs, of ancient Egypt.

Ancient Egyptians believed their pharaohs were gods who would have two lives. They believed the second life would begin when the pharaoh died.

The tombs (burial places) of the pharaohs were built with rooms and halls. Some tombs were built into the side of a mountain. Others were great pyramids.

The tombs were filled with artwork. The artwork was created to help spirits recognize the pharaoh and everything he would want or need in the afterlife. Many artists worked on paintings, sculpture, furniture and other kinds of art for the tombs.

A *Statuette of Min-Nefer.* late Dynasty V. Egyptian. Limestone with polychrome, 6¾ × 23¼″ (17 × 59 cm). The Cleveland Museum of Art, Ohio (Purchase from the J. H. Wade Fund).

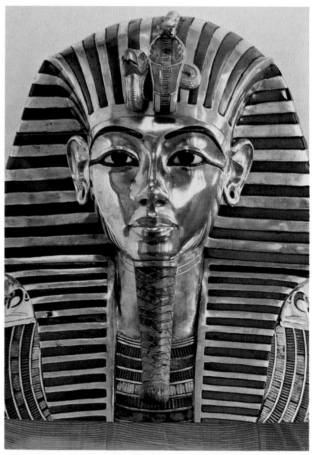

B *Mask of King Tutankhamen,* 1352 B.C. 18th dynasty. Gold with precious stones and glass, life sized. Thebes. Cairo Museum, Egypt.

The tombs of the pharaohs were built thousands of years ago. Some of the artwork has been saved. Examples of ancient Egyptian art can be seen in museums all over the world. Some examples may be in a museum that you could visit.

Imagine that your classroom is a sculpture studio in ancient Egypt. Practice carving clay to make a relief sculpture.

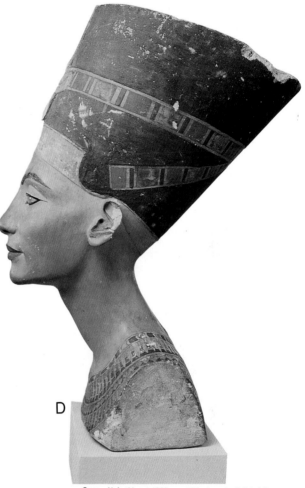

D

Queen Nefertiti, ca. 1360 B.C. 18th dynasty. Painted limestone, 20″ (51 cm). El Amarna. States Museum, Berlin.

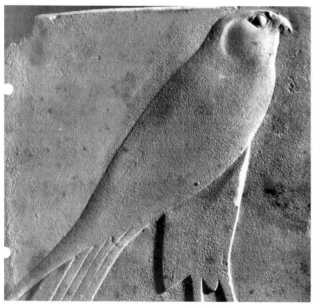

C

Falcon. Egyptian bas-relief. Cairo Museum, Egypt.

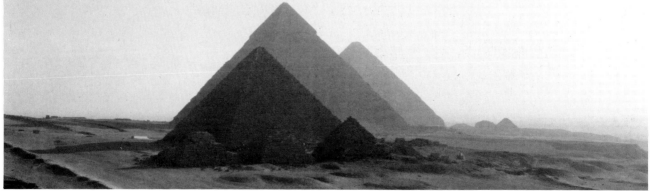

E

Egypt, Giza. Pyramids, 4th Dynasty, Menkaure, Khafre, Khufu. View from south.

33

A Symmetrical Vase Design
Ancient Greek Art

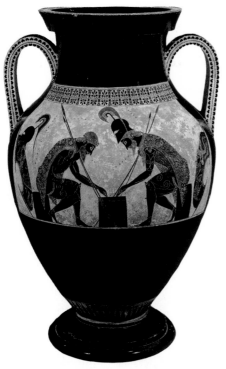

A

Courtesy Vatican Museums, Rome.

The ancient Egyptians created many works of art for tombs. The ancient Greeks created artwork about living people such as athletes and soldiers. They also created artwork to honor their gods and goddesses.

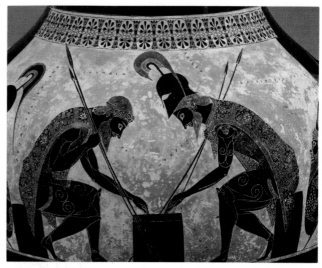

B

Exekias, *Ajax and Achilles Playing Draughts,* 550-525 B.C. Vase painting. Vatican Museums, Rome.

The ancient Greeks created many beautiful vases from clay. Picture B is a close-up view of the design on the vase in picture A. The design shows two warriors playing a game of checkers. The vase is about 2500 years old.

Some shapes of ancient Greek vases are shown in picture C. The shapes are symmetrical. **Symmetry** means both sides are the same or nearly the same.

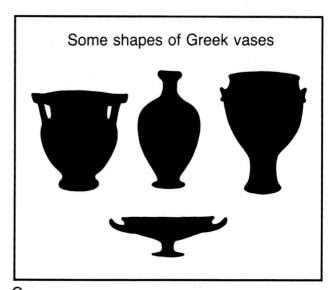

Some shapes of Greek vases

C

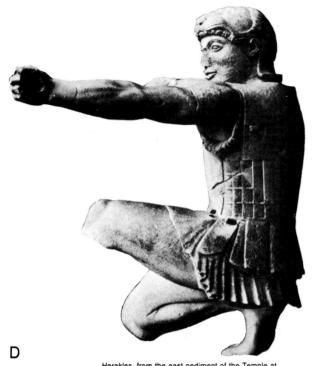

D

Herakles, from the east pediment of the Temple at
Aegina. *ca.* 490 B.C. Marble, 31″ (79 cm). Glyptothek, Munich.

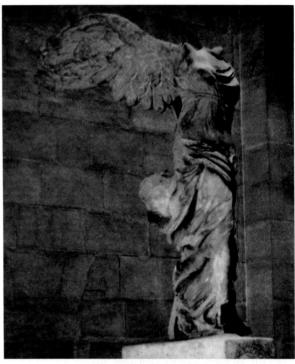

E

Winged Victory (Nike) of Samothrace, ca. 190 B.C.
Marble, 8′ (244 cm). Louvre, Paris.

This sculpture was carved from stone about 2400 years ago. It shows a Greek warrior. His hands once held a bronze bow for shooting arrows.

The ancient Greeks were very interested in sports. Our Olympic games of today came from the ancient Greek culture. The sculptors of ancient Greece carved many beautiful sculptures of athletes and warriors.

This sculpture of a Greek goddess is about 2200 years old. The head was destroyed long ago but many people still admire the sculpture. It was carved in stone to help celebrate a military victory. It is often called the *Winged Victory.*

Imagine you could design a vase for a special person or event. Design and cut out a symmetrical shape for a vase, then decorate it. You might draw a picture on part of it.

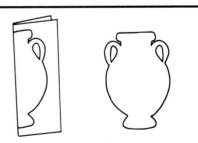

Fold the paper. Draw half of the vase, then cut it out.

F

Proportions in Faces
Ancient Roman Portraits

Ancient Greek artists invented many rules of measurement to design their buildings, sculpture and other artwork. These rules of measurement are called **proportions.** Many people have admired the proportions used by Greek artists.

The Romans conquered the Greeks in about 200 B.C. The Romans admired and borrowed many Greek ideas about art. The Romans also had their own ideas about art. You can see these differences in sculptures of people.

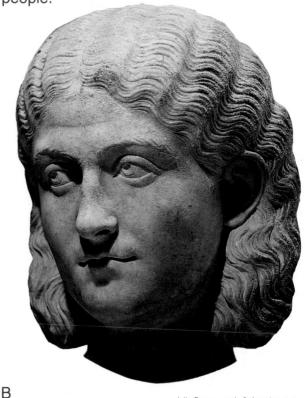

A

Aphrodite, 2nd century B.C. Greek, from Armenia. Bronze, 12″ (30 cm). The British Museum, London.

B

Julia Domna, early 3rd century A.D. Metropolitan Museum of Art, New York.

This sculpture is about 2100 years old. It was made to honor Aphrodite, the Greek goddess of love. The artist did not observe the face of a real person to create this sculpture. The artist followed rules of proportion instead. This sculpture shows a kind of beauty admired by the Greeks.

This Roman sculpture was created about 1600 years ago. It is not meant to show a specific kind of beauty. This sculpture is a portrait. A **portrait** is a likeness of a real person.

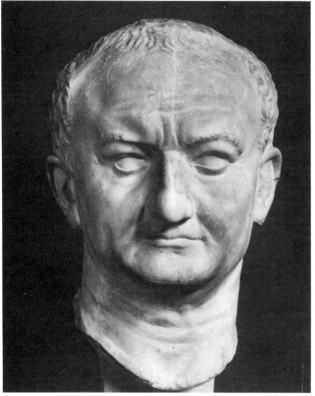

C

Head of Vespasian, ca. 75 A.D. Marble.
Collection of the National Museum of Rome, Italy.

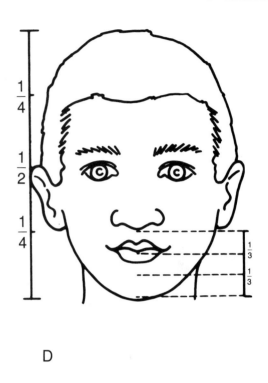

D

The Romans created artwork about real people. This Roman sculpture is a portrait of a man who lived about 1900 years ago.

You can combine Greek and Roman ideas to draw faces. First draw a face using the rules of measurement in picture D. Draw a large oval. Divide the oval as the face is divided in picture D. Draw the hairline, ears, eyes, nose and lips. Draw very lightly.

Now change your drawing so it looks like a real person. Children drew the portraits in picture E.

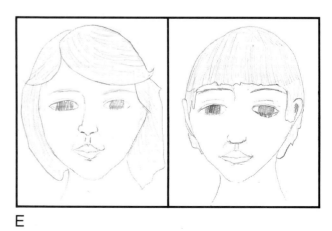

E

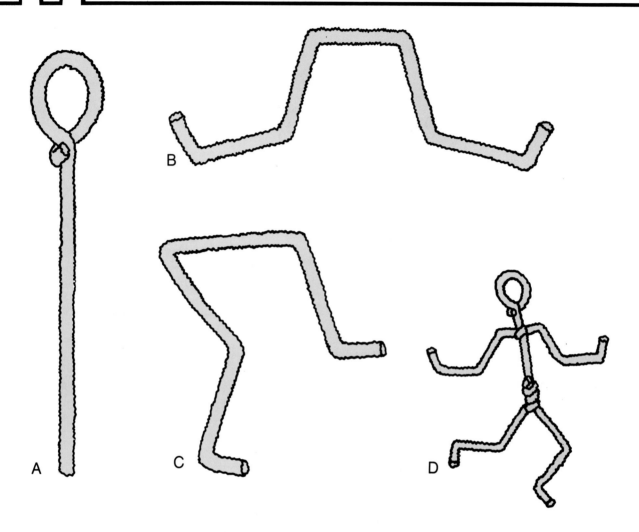

A

B

C

D

In almost every culture, artists have included people in their artwork. You can learn to include people in your artwork, too. You can practice drawing people from a model made of three pieces of wire.

Put your wires together. Imagine the wires are like the skeleton of a person. Bend the wires at the knees, hips, elbows and shoulders. What other parts of a person's body can bend?

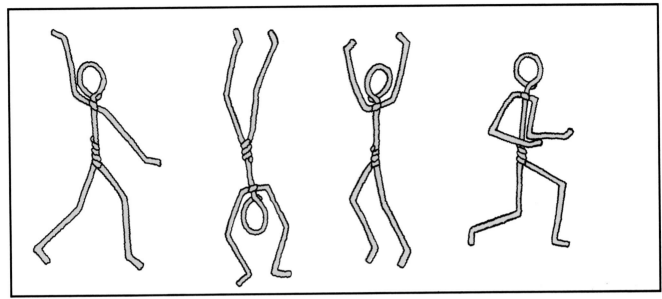

E

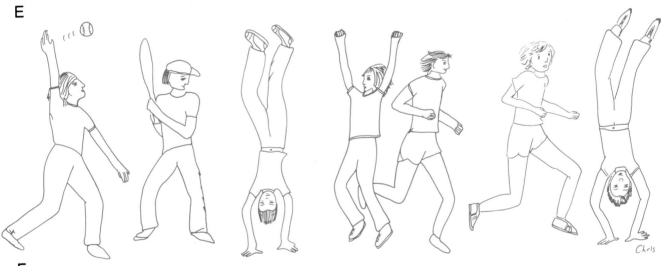

F

Create some interesting poses with your model. Choose one or two poses to draw on paper. Draw the "skeleton" lightly. Then add details to show what the person is doing.

Artists practice drawing people. They often use diagonal lines to show action and movement. Your model can help you learn to show the diagonal lines of people in action.

Sculptures of People
Making Clay Sculptures

Many artists make sketches or models just for practice. Art created for practice is called a **study.**

Today you will make a clay study of the human figure. This lesson shows three ways to create a figure. Decide which way you will begin your sculpture.

A

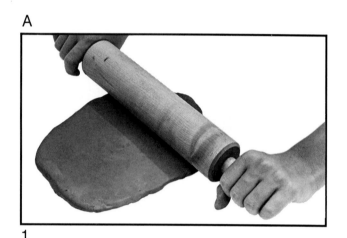

1

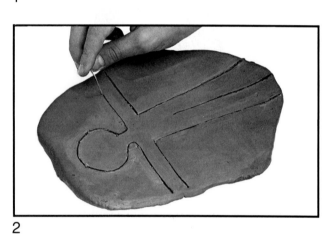

2

3

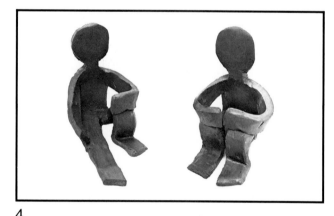

4

Slab Method

1. Make a flat slab of clay larger than your hand and as thick as a pencil.

2. Sketch the outline of a person on your clay. Use a paper clip to cut out the figure.

3. Remove the extra clay and save it.

4. Gently bend the arms and legs of the clay figure. Try several positions. Smooth the parts and add details.

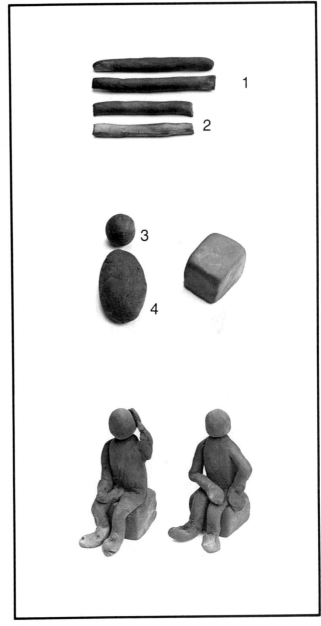

B

Carving

1. Press all of your clay together.
2. Imagine you can see a person inside the clay form.
3. Subtract or carve away the clay with a paper clip.

C

Coil Method

1. Legs: Roll two coils about 5 inches long (13 cm) and as thick as your middle finger.
2. Arms: Roll two coils about 4 inches long (10 cm) and as thick as your little finger.
3. Head: Make an egg shape as long as the end of your thumb. Join all the parts firmly and add details.
4. Body: Make a clay oval about half as big as your fist.

41

Art can be full of surprises. Look carefully at the face of the baboon. Do you see the form of a toy automobile?

Pablo Picasso created this sculpture. He saw a toy car. The form of the toy car reminded him of a baboon's head. He created a sculpture by seeing a similar form in two different things.

Pablo Picasso discovered new ways to make art. He looked at things carefully. He often created surprises in his sculptures, paintings and other art.

You can make an inventive sculpture. Choose an object and study its form. Think of other things that have a similar form. Make a sculpture that combines the forms in a new way.

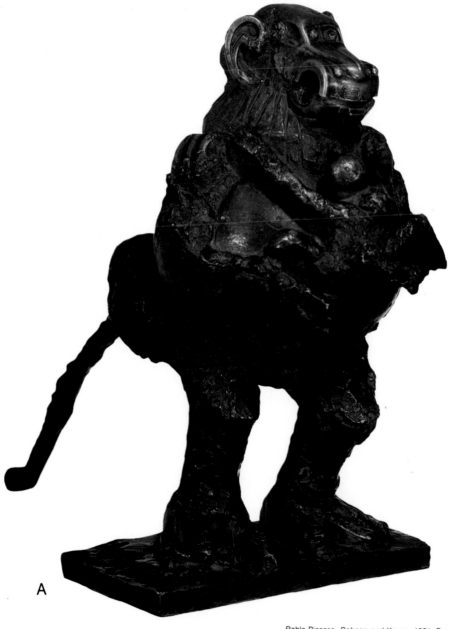

A

Pablo Picasso, *Baboon and Young*, 1951. Bronze, cast 1955, after found objects, 21" high; 13¼ × 6⅞" (base) (53 cm high; 34 × 18 cm). Collection, The Museum of Modern Art, New York (Mrs. Simon Guggenheim Fund).

This sculpture was created by Patricia Renick. She saw a similar form in plastic models of a car and a dinosaur. She put the models together in a new way. Then she built this huge sculpture around a real automobile.

Patricia Renick also found similar meanings in cars and dinosaurs. Dinosaurs vanished because they ran out of food. Cars could vanish if we had no fuel to "feed" them. Art can make you think. Think about cars and endangered or extinct animals. Can you find other similarities?

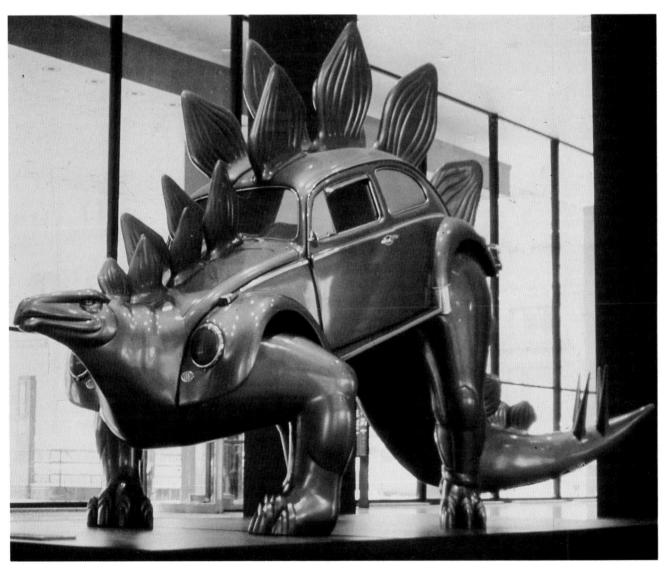

Patricia Renick, *Stegowagenvolkssaurus*, 1974. Steel and fiberglass, 12 × 7 × 20' (366 × 213 × 610 cm).

20 Unity in Art
Repetition

Artists in many lands have included animals in their art. Sometimes artists change the shapes they see in real animals. Artists often do this to create a unified design. In a **unified** design, all the parts are planned in relation to the other parts.

The bowl from Peru, in picture A, is about 1300 years old. The artist curved the shape of the shark to fit the shape of the bowl. The design is unified.

Picture B is an art print by a Kwa-Gulth Indian from western Canada. The artist repeated curved lines and shapes to unify the design.

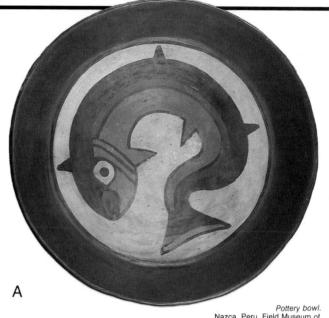

A

Pottery bowl.
Nazca, Peru. Field Museum of
Natural History, Chicago, Illinois.

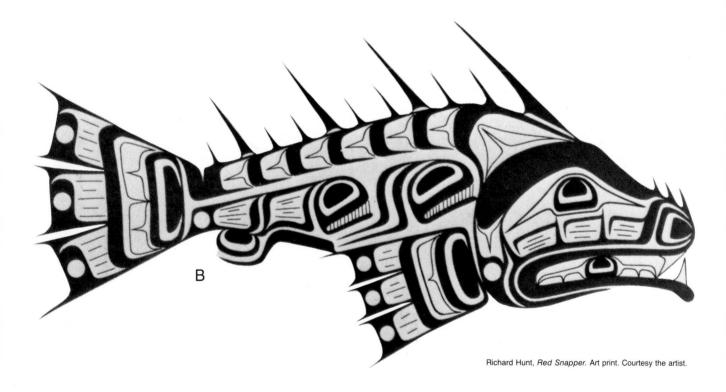

B

Richard Hunt, *Red Snapper.* Art print. Courtesy the artist.

The ceramic bottle in picture C was made about 2400 years ago in Peru. The design is unified by the round form and curved lines on the head of the fish. The light and dark pattern on the body is very bold, like the lines on the head. The design is unified by many repeated lines and shapes.

The fish-shaped bottle in picture D is made of colored glass. It was created in Egypt about 3300 years ago. How did the artist unify the design?

Artists often choose a limited number of lines, shapes and colors for a design. They repeat the same or very similar lines, shapes and colors so all parts of the design look like they belong together.

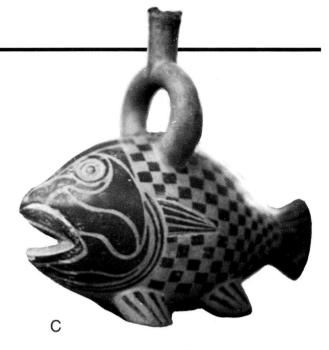

C

Stirrup vesel in the shape of a fish. Mochica culture, Peru. Hand-formed clay, 9″ (24 cm). Ohara Museum of Art, Kurashiki, Japan.

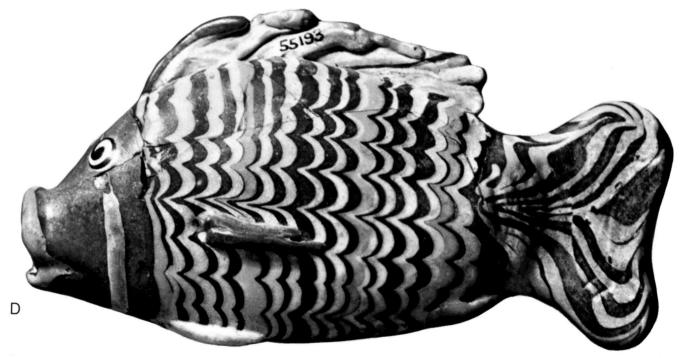

D

Glass bottle shaped like a fish, ca. 1370 B.C. Egyptian, from el Amarna. Glass, 5½″ (14 cm). British Museum, London.

Draw a fish, bird or insect. Show what you have learned about repeating lines, shapes and colors to create a unified design.

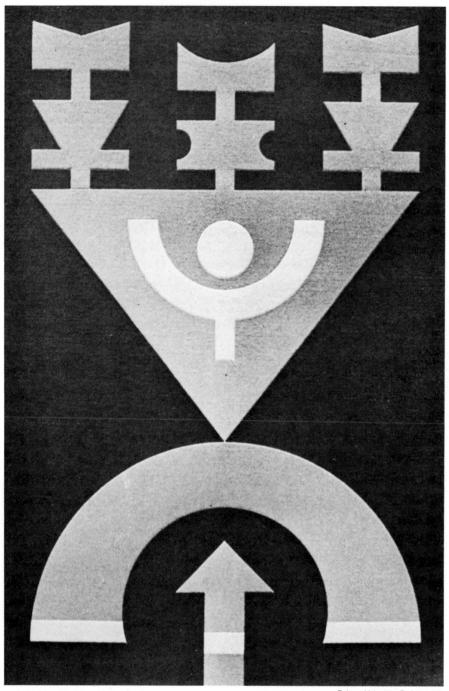

A

Rubem Valentim, *Emblem #6.*

Artists can unify a work by repeating lines, shapes and colors. **Balance** is another way to unify a work of art. Creating visual balance is similar to balancing objects on two sides of a scale or balance board. The objects on each side do not have to be the same.

The artist who created this image used formal balance to unify the design. **Formal balance** means that both sides of the design are the same or similar. Formal balance usually makes a design look very stable, still, strong or unchanging.

46

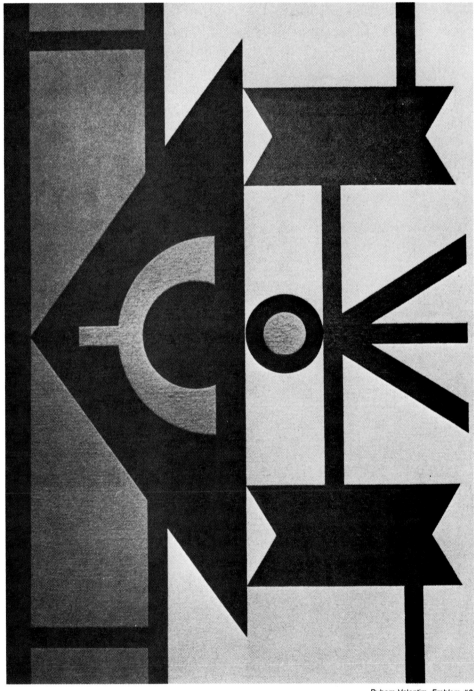

B

Rubem Valentim, *Emblem #3*.

This design has informal balance. **Informal balance** means that both sides look equally important even if they are not the same. In this design, the large arrow on the left is balanced by several smaller shapes on the right.

Informal balance usually makes a design look busy, active or full of energy.

Both of these designs were created by Rubem Valentim. He used similar shapes in each design. Which design do you prefer? Why?

Many architects, sculptors and other artists study **three-dimensional design.** They learn to create objects that can be seen from all sides. Three-dimensional art has height, width and depth. It is not flat.

Today you will use straws to create three-dimensional designs. You might design the skeleton for a building or a bridge. Your design could be a piece of jewelry or a holiday ornament.

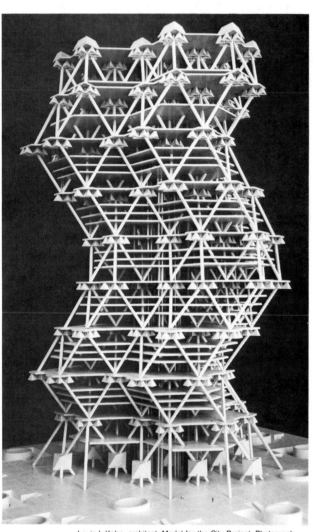

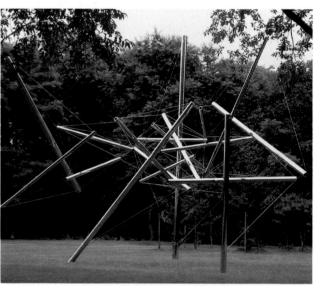

B Kenneth Snelson, *Mozart I,* 1982. Stainless steel, 24′ × 30′ × 30′ (7.3 × 9 × 9 m). Collection Stanford University. Courtesy the artist.

An artist created this sculpture from shiny metal pipes. Many artists first design a large sculpture by creating small models from paper or other materials. You could design a sculpture from straws.

A Louis I. Kahn, architect. Model for the City Project. Photograph courtesy of the Louis I. Kahn Collection, University of Pennsylvania and Pennsylvania Historical and Museum Commission.

This is a three-dimensional design for an office building. The small model is made from balsa wood and cardboard. The triangles show how steel beams could be joined in a real building. An American architect, Louis Kahn, created this design.

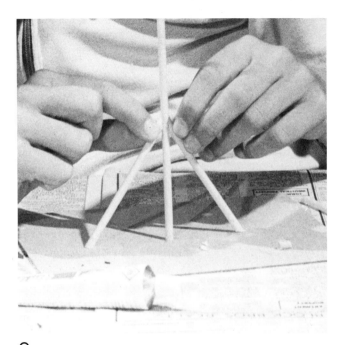

C

You can join straws in many ways. This student is beginning with a very strong triangular base for a sculpture. Other ideas are shown below.

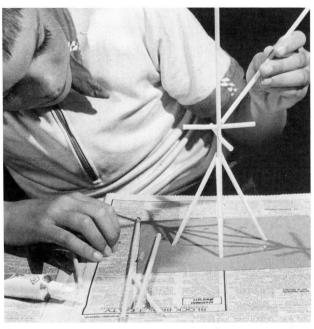

D

Try different arrangements of your straws. You might create two or three shapes and then join them together. Be creative!

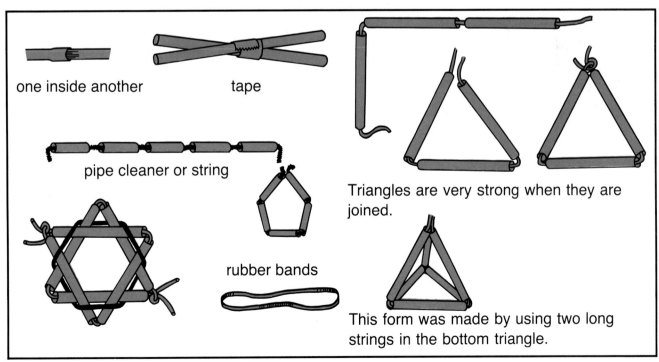

one inside another tape

pipe cleaner or string

rubber bands

Triangles are very strong when they are joined.

This form was made by using two long strings in the bottom triangle.

E

23

Architecture
Ancient and Modern Buildings

Architecture is the art of designing buildings. Architecture was important in Egypt, Greece and Rome. It is important today, too.

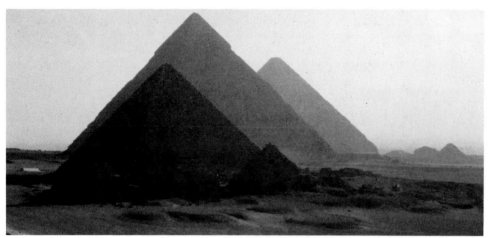

A

Egypt, Giza. Pyramids, 4th Dynasty, Menkaure, Khafre, Khufru. View from south.

These pyramids were built in Egypt more than 4000 years ago. They are constructed from stone. They were used as tombs for pharaohs. The largest pyramid is about 480 feet high (146 m).

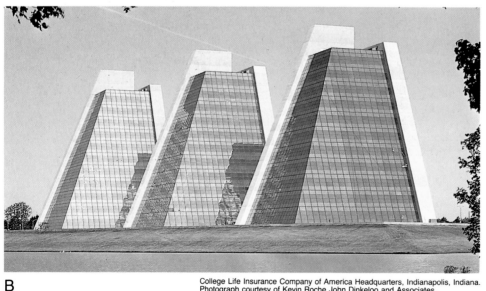

B

College Life Insurance Company of America Headquarters, Indianapolis, Indiana. Photograph courtesy of Kevin Roche John Dinkeloo and Associates.

These modern buildings are made from steel and covered with mirror-like glass.

How are these modern buildings like the pyramids of ancient Egypt? How are they different? Do you think the modern buildings will last 4000 years?

In most large cities you can see buildings that have forms and art ideas that began in ancient Greece.

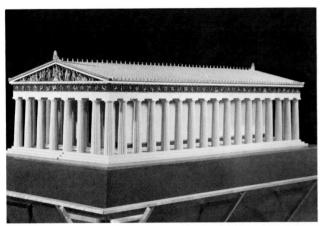

C

Model of the Parthenon. The Metropolitan Museum of Art, New York (Levi Hale Willard Bequest, Purchase 1890).

This is a model of the Parthenon, a temple built in ancient Greece. Many architects have admired the columns, proportions and carvings.

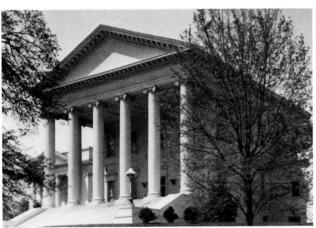

D

Capitol. Richmond, Virginia. Architect: Thomas Jefferson. Photograph courtesy of the Virginia State Travel Service.

Thomas Jefferson, an American president, was also an architect. He designed this building. What parts are similar to the Parthenon?

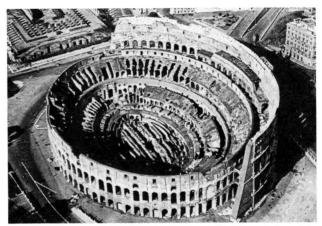

E

The Colosseum, Rome, Italy.

The ancient Romans built this huge colosseum for their sports and festivals. The building was constructed from large blocks of stone.

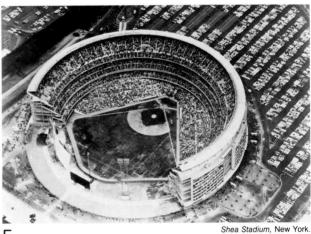

F

Shea Stadium, New York.

This modern colosseum is in New York City. It was constructed from concrete and steel.

Imagine you could design a building that would last 1000 years or more.

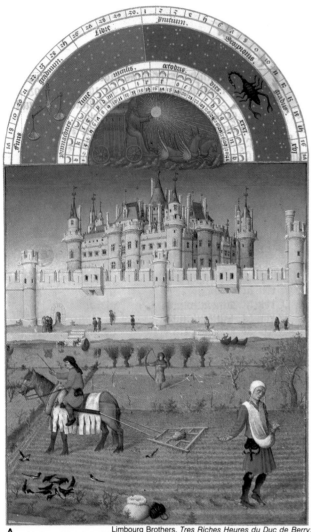

A Limbourg Brothers, *Tres Riches Heures du Duc de Berry: October.* Chantilly, Musée Condé. Photograph courtesy Art Resource, New York.

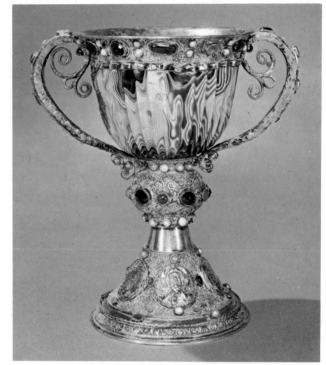

B *Chalice of Abbot Suger of Saint-Denis.* Sardonyx, gold, silver-gilt, gems and pearls, 7 ¹¹/₃₂" (19 cm). National Gallery of Art, Washington, D.C. (Widener Collection, 1942).

This painting is part of a handmade book created during the Middle Ages. The Middle Ages began around 440 A.D. when the Roman empire was destroyed. It was destroyed by warlike tribes known as barbarians.

The Middle Ages lasted for about 1000 years. People found safety by living near large churches. Wealthy people built castles to protect themselves and their servants. Notice the castle, moat and servants in this painting.

This gold cup has decorations made from silver, pearls and other costly materials. During the Middle Ages, most artists worked for wealthy nobles or created art for churches. Artists were called **artisans** or **craftsworkers.** These words mean that a person is very skillful in making objects.

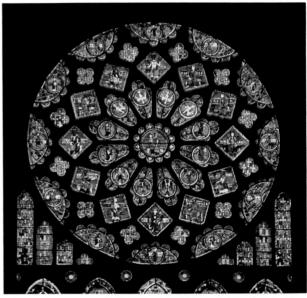

Rose window, ca. 1230. Chartres Cathedral, Notre Dame, France.

D

You can cut a radial design from paper. Begin with a square. Picture E shows how to fold it. Draw an original design with wide spaces between the shapes. Cut out the shapes.

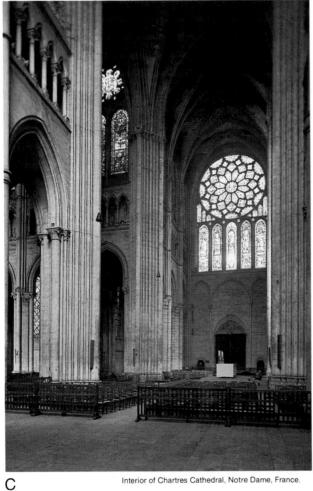

C

Interior of Chartres Cathedral, Notre Dame, France.

Many skilled workers helped build great churches such as this one in France. The round window has a **radial** design. The open spaces are filled with stained glass. Windows like this one are called **rose windows.**

E

53

Art and History
Art of the Middle Ages

During the Middle Ages, artists often created pictures to tell stories. Picture A is a work of art that tells about a famous battle in England. The battle was won by William the Conqueror in 1066. Look at the details. They tell how battles were fought long ago.

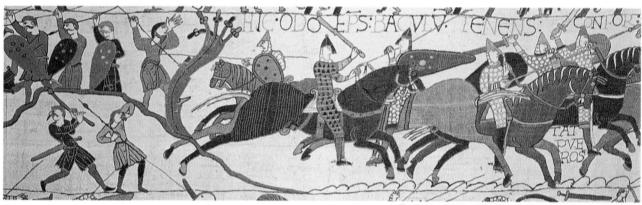

A

The Battle of Hastings, detail of the Bayeux Tapestry, *ca.* 1073-1083. Wool embroidery on linen, 20″ (51 cm). Town Hall, Bayeux, France.

Artists created this picture more than 900 years ago. The picture was embroidered in cloth with a needle and thread. The whole picture is 230 feet long (70 m) and 20 inches high (51 cm).

Picture A is a photograph of stitched artwork. This artwork is called a tapestry. A true **tapestry** is artwork woven from thread or yarn. Large tapestries were created to hang on castle walls. The tapestries helped to block out the cold air in winter.

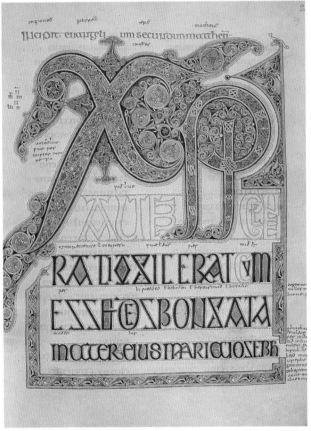

B

X-P (Chi-Rho) Page. From *Lindisfarne Gospel Book,* 698-721. Miniature on parchment, British Museum, London.

During the Middle Ages, every book was made by hand. The words were copied using pen and ink. The most beautiful books also had fancy designs and drawings. These books are called **illuminated manuscripts.**

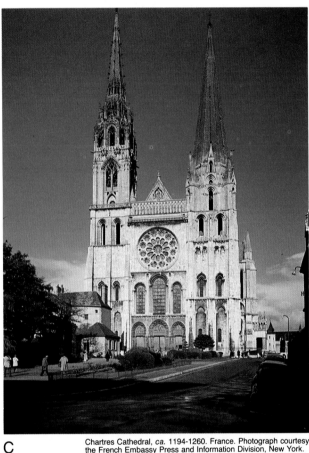

C

Chartres Cathedral, *ca.* 1194-1260. France. Photograph courtesy the French Embassy Press and Information Division, New York.

This photograph shows a cathedral that was built in France during the Middle Ages. The cathedral's spires tower over the entire town and can be seen from many miles away.

Finish cutting out your radial design. Then add colored cellophane or tissue paper to the back. Use glue or tape. Hold your design up to a strong light. How is the design similar to a stained glass window? How is it different?

Crafts
Making Beautiful Objects

People around the world have crafted beautiful objects by hand. Some handcrafted objects have original designs and are skillfully made. People who create this fine artwork are **artisans.**

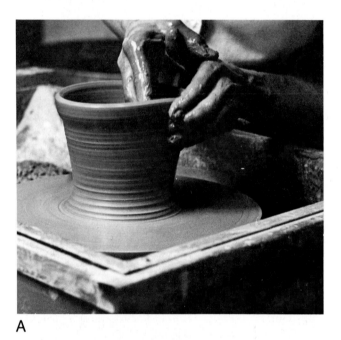

A

Picture A shows an artisan creating a vase from wet ceramic clay. The clay is placed on a flat wheel called a "potter's wheel." When the wheel is turned rapidly, the artisan can pull and stretch the clay to form a vase, a bottle, a plate and other objects.

Objects made from ceramic clay are placed in a **kiln,** a special furnace. The intense heat hardens the clay. Artwork made in this way is called **ceramics.**

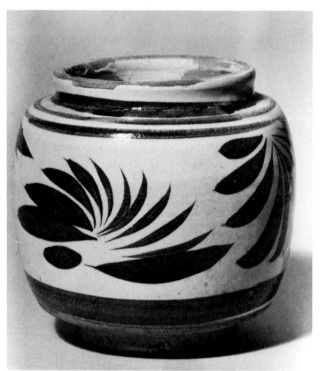

B — White jar with stylized flowers in gray. China, Sung Dynasty, 960-1280. 3½" high (9 cm). The Metropolitan Museum of Art, New York (Bequest of Robert West, 1950).

This Chinese ceramic vase is more than 1000 years old. The design was masterfully applied with a brush. Notice the shape of each brushstroke.

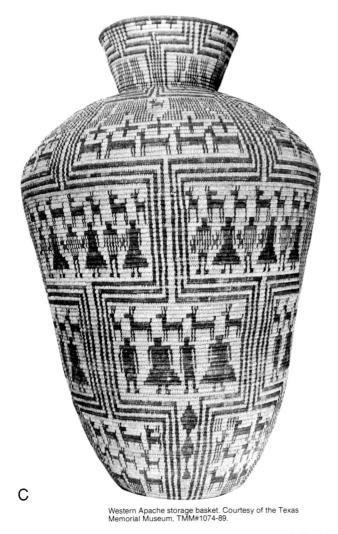

C

Western Apache storage basket. Courtesy of the Texas Memorial Museum, TMM#1074-89.

This storage basket was carefully designed and woven by an Apache Indian artisan. Weaving, wood carving, metal working and glass making are ancient crafts.

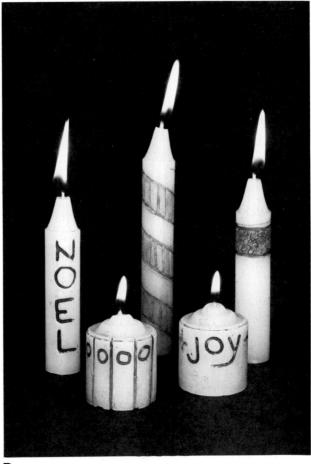

D

You can skillfully decorate a candle, as an artisan would. Try this.
1. Cut a sheet of paper so it just wraps around the candle. Draw an original design on the paper.
2. Paste the paper to the candle. Use a sharp pencil to trace the design in the wax.
3. Remove the paper. Carefully retrace the grooves so they are easy to see.
4. If you wish, brush paint into the grooves. Let the paint dry. Rub the candle with a paper towel to remove any excess paint.

Printmaking
Surface Designs

Artists create the designs you see on wallpaper, gift paper, fabrics and linoleum. A design created for a large surface is called a **surface design.**

Today most surface designs are printed by machines. Long ago, surface designs were printed by hand.

Two blocks of wood were used to print this wallpaper design. It was printed by hand about 150 years ago. Thick ink was rolled on each block. The blocks were printed many times on long sheets of paper.

This wallpaper has a **regular** or even pattern that covers the whole surface.

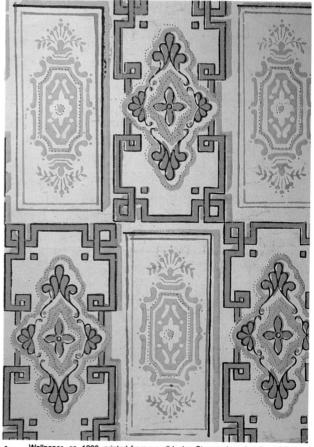

A Wallpaper, ca. 1830, printed from woodblocks. Strapwork and stylized foliation, green and grey on pale grey ground. The Cooper-Hewitt Museum, Smithsonian Institution/Art Resource, New York.

You can make a printing stamp from a small piece of clay. Do you see how? Plan your stamp's shape and design.

C

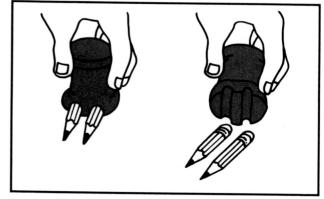

Press objects into clay. Remove the objects.

A surface design can have a regular or an irregular pattern. In an **irregular** pattern, the design is not exactly the same over the whole surface.

This fabric design has an irregular pattern. What elements are repeated? What elements are varied? Study the lines and the white shapes.

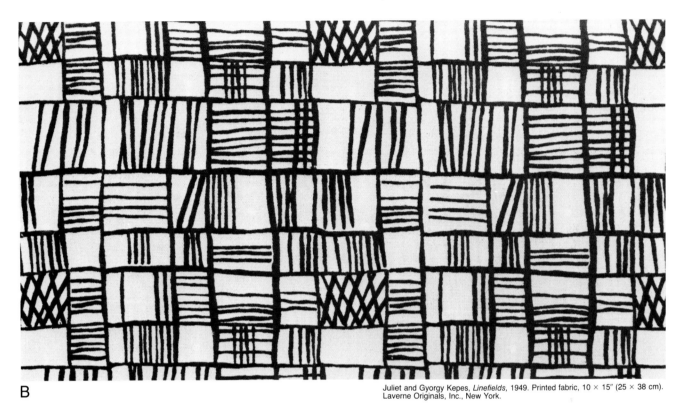

B

Juliet and Gyorgy Kepes, *Linefields*, 1949. Printed fabric, 10 × 15″ (25 × 38 cm). Laverne Originals, Inc., New York.

Today you will design and print some large sheets of gift wrapping paper. Will your design have a regular or an irregular pattern?

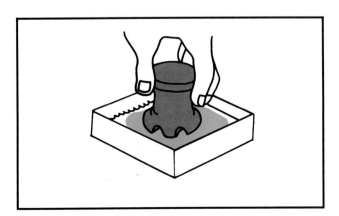

Put paint on the clay stamp.

Press your stamp on paper. Press very gently!

59

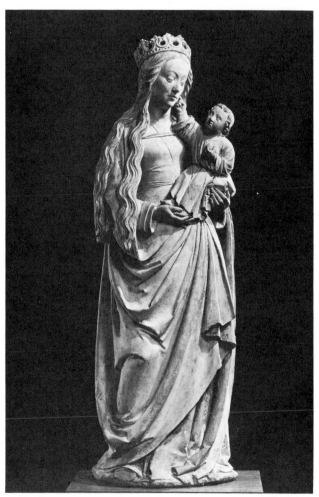

A

Madonna and Child, ca. 1475. French, School of Troyes.
Stone, 35¼ × 11½" (89.5 × 29 cm). William Rockhill Nelson
Gallery of Art, Kansas City, Missouri (Nelson Fund).

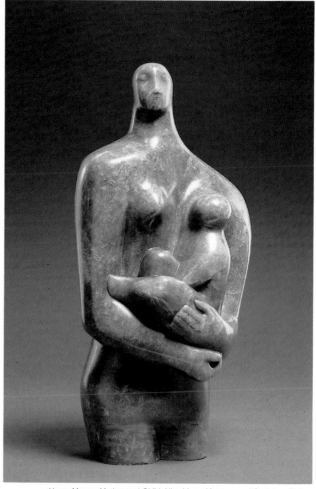

B

Henry Moore, *Mother and Child.* Hirschhorn Museum and Sculpture Gallery,
Smithsonian Institution, Washington, D.C.

Experts in art learn to see similarities and differences in artwork. You can learn to see and discuss artworks as experts do.

Study the **subject matter** of the artwork. Sometimes the subject is the design. Sometimes the subject is something you can recognize, such as a mother and child.

Look at each sculpture shown here. Do the mothers and children look alike? How are they different? Study the poses, clothing and other details.

Study the **design.** The design is the artist's plan for using lines, shapes and other visual elements. The design helps create a mood or feeling that goes with the subject.

Look for the sculptures that have these design elements:

1. Many forms are large, smooth and rounded. There are few details.
2. Many forms are small. Lines and edges create many details or textures.
3. The textures of the clothing look like real cloth.

Can you find other differences or similarities in the sculptures?

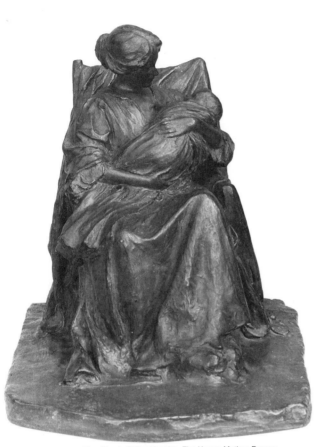

C

Mrs. Bessie Potter Vaughn, *The Young Mother*. Bronze.
The Metropolitan Museum of Art, New York. (Rogers Fund, 1906).

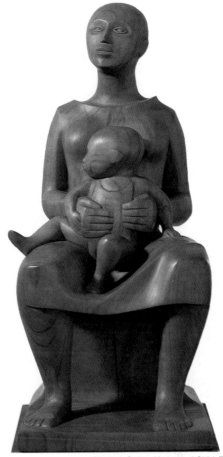

E

Elizabeth Catlett, *Mother and Child*. The Museum of
African American Art, Los Angeles, California.

In many sculptures, the artist uses some "hidden" design elements. For example, these sculptures have paths of movement. The paths draw your eyes in certain directions. They help you see different parts of the sculpture.

Look at the **materials.** Notice how the artist used them as part of the design. Three of these sculptures were carved from hard materials. Can you guess which sculpture was first created with a soft material like clay or wax?

Sketch the sculpture you like best. Then write down why you like it. Give reasons for liking the subject matter, the design and the way the artist used the materials.

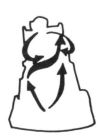

D

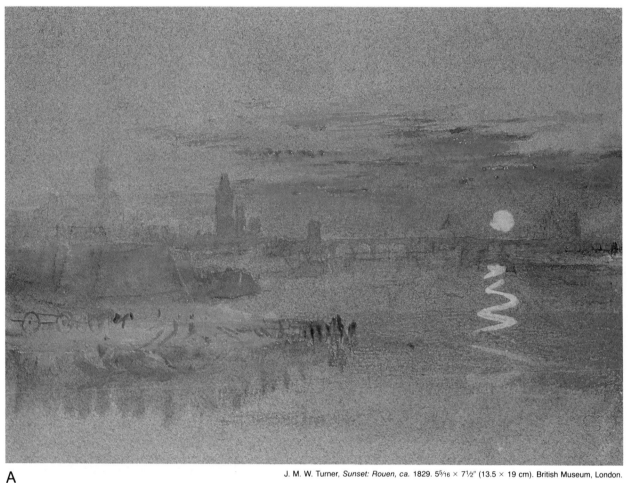

A

J. M. W. Turner, *Sunset: Rouen, ca.* 1829. 5⁵⁄₁₆ × 7½″ (13.5 × 19 cm). British Museum, London.

Have you ever watched a sunrise or a sunset? What colors have you seen at each time of day? Could you create a picture that captures the light and color of a special time of day?

Study the colors in J. M. W. Turner's painting. The painting was created on blue paper. The evening light glows in the sky.

Notice the warm and cool colors in the painting. Are most of the cool colors light or dark? Are most of the warm colors light or dark?

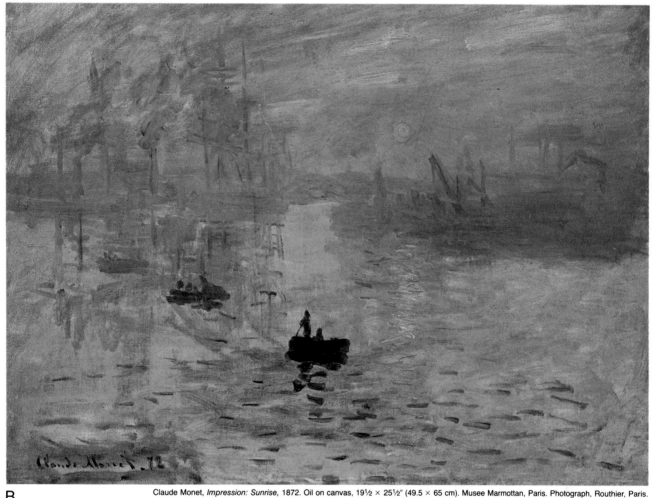

B

Claude Monet, *Impression: Sunrise,* 1872. Oil on canvas, 19½ × 25½″ (49.5 × 65 cm). Musee Marmottan, Paris. Photograph, Routhier, Paris.

Claude Monet's painting of sunrise also seems to glow with color. The morning sun lights up the sky, the city and the water.

Study the small differences in all of the colors. Look for differences in the lightness of the warm and cool colors. Which colors are darkest?

Artists learn to see very small differences in color. They learn to create artworks that have mixtures of colors.

Create a picture with many small differences in color. Show a special time of day.

Many buildings in North America have forms that were first used in other lands hundreds of years ago. Art ideas spread from one country to another.

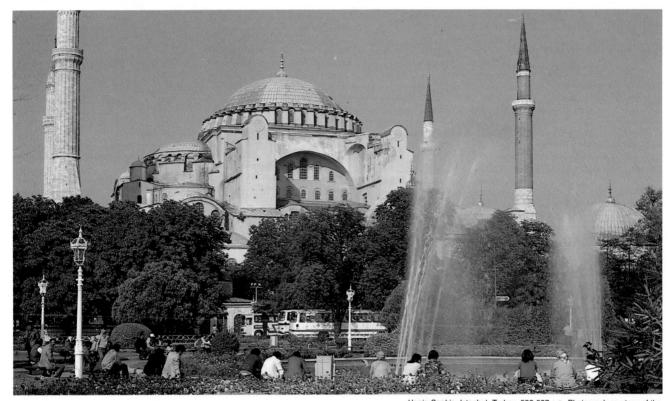

A

Hagia Sophia, Istanbul, Turkey. 532-537 A.D. Photograph courtesy of the Information Counselor, Embassy of Turkey, Washington, D.C.

This church was built more than 1400 years ago in a town that was once part of the Roman Empire. It has **rounded arches** and **domes** like those of many ancient Roman buildings.

The church is now a museum. It is in Istanbul, Turkey.

B

Today you will construct a model of a building. Think about using art ideas from ancient or modern architecture. You could use ideas from buildings in your town.

You can begin a model this way. Glue or tape some forms together. Try different arrangements. You will finish your model in the next lesson.

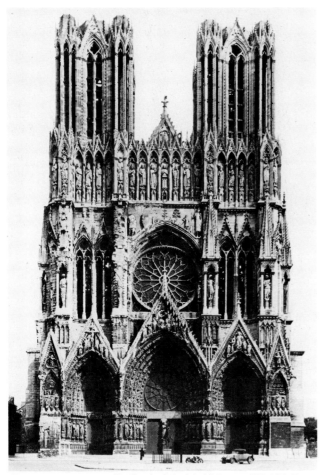

C *West facade, Cathedral of Reims, ca. 1225–1299. France.*

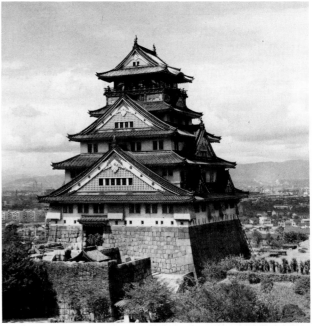

D *Osaka Castle, late 16th century. Osaka, Japan.*

Have you seen any buildings with forms and shapes like the ones in this church? In the Middle Ages, people in Europe invented new ways to build great castles and tall churches.

This church in Reims, France, is about 700 years old. It has **pointed arches** and thin **columns.** The sculptures are carved from stone.

The round window is a rose window. The openings are filled with stained glass.

This Japanese castle is about 400 years old. It shows that art ideas spread from one country to another.

The wide roofs came from the Chinese people. European traders taught the Japanese about medieval castles. Both ideas are combined in this building.

Many architects plan buildings with forms like these. Can you explain why?

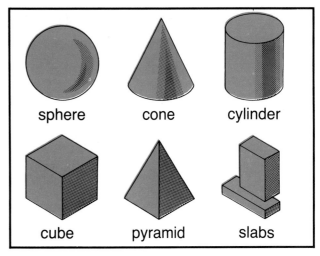

E

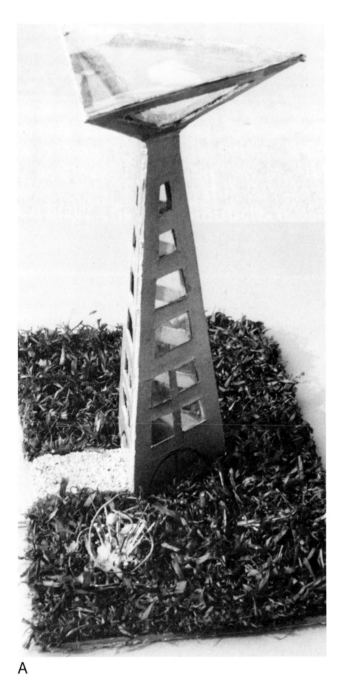

A

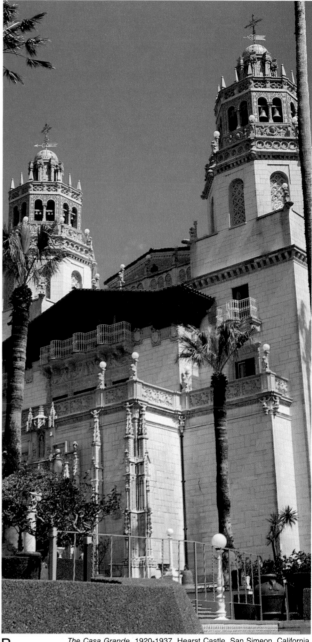

B *The Casa Grande*, 1920-1937. Hearst Castle, San Simeon, California. Photograph courtesy of Hearst State Monument.

Today you will finish your architectural model. Paint your model first. While the paint is drying, cut out some paper shapes to show windows, doors and other details.

Often architects create models to see how a building might look. Would you like to become an architect? A seventh grade student made this model of a park tower.

Julia Morgan was among the first women in America to be trained as an architect and engineer. She completed more than five hundred projects for buildings.

Julia Morgan designed this Spanish-style mansion for a man who collected many kinds of art. The mansion is now used as an art museum. It is in California.

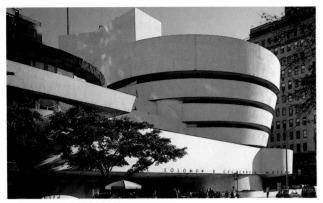

C Exterior of Solomon R. Guggenheim Museum, New York.
Photograph: David Heald.

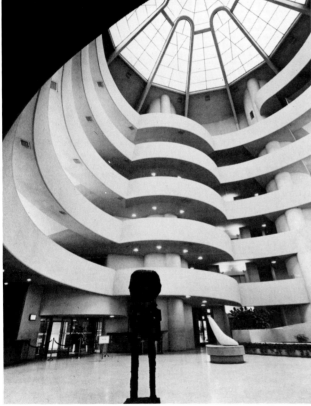

D *Interior of The Solomon R. Guggenheim Museum, New York.*
Photograph: Robert E. Mates.

Frank Lloyd Wright was one of America's most inventive architects. He designed this art museum in New York City.

Today, architects can use concrete, steel and other materials to create buildings with unusual forms and spaces.

Arthur Erickson designed this museum in Canada. The museum has an outstanding collection of totem poles and other kinds of art created by native Americans.

The architect used large beams to support the roof. The walls are glass. Some of the building's forms are like the greet long houses built by the Northwest Indians.

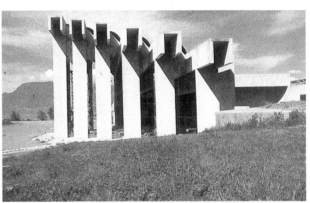

E The University of British Columbia's Museum of Anthropology, Vancouver, Canada. Building exterior.

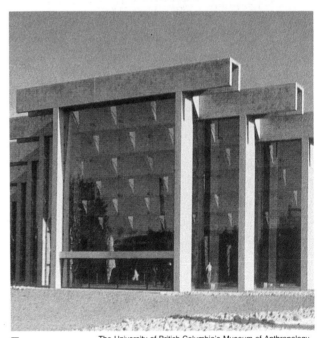

F The University of British Columbia's Museum of Anthropology, Vancouver, Canada. Building exterior, Great Hall.

The Cincinnati Ballet Company Presents the

NUTCRACKER

Music Hall
December 21-30
Five matinees and
five evening
performances

This production is
sponsored by
Frisch's Restaurants, Inc.

CINCINNATIBALLET
David McLain, Artistic Director

A

Photograph: Jeff Kauck. Courtesy of
Kauck Photography, Inc., Cincinnati, Ohio.

B

C

Graphic designers are artists who plan the lettering and the artwork that you see in posters, signs and advertisements. Graphic designers also plan the lettering and some of the artwork for books, newspapers, packages and other things you see.

This kind of graphic design is a logo. A **logo** is a symbol for a business or a group. People learn to recognize familiar logos. A logo is like a trademark. It can be printed on stationery or used on other objects such as signs and uniforms.

D

F

G

E

Postage stamps are planned by graphic designers. The designer creates a **layout** that has all the lettering and artwork for the stamp. The layout for a stamp is usually 12 times as large as the final stamp.

When the layout is finished, it is given to a printing company. Special cameras are used to reduce the design to the size of a stamp. Then many copies of the design are printed on large printing presses.

Postage stamps can be used to honor important people or events. Sometimes stamp designs honor groups of people such as nurses or farmers. Some stamps help people remember important ideas such as protecting endangered animals or working for peace.

You can create a design for a postage stamp. What should your layout include? What will make your design easy to see? Whom or what will your design honor?

A

A **symbol** is something that stands for something else. A heart-like shape is a visual symbol for friendship or love. Many other shapes, lines and colors are visual symbols. Can you name some?

The heart shape has been used for a long time. It is a **traditional** symbol. Many people know that it stands for friendship or love.

Creative artists use traditional symbols in a new or unexpected way. Study these two examples of artwork. How did each artist use a traditional visual symbol? What makes each work of art creative?

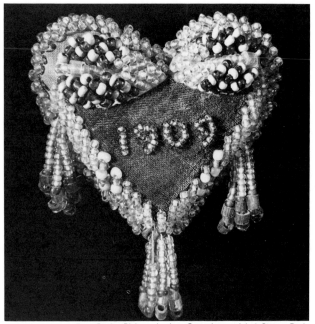

B

From *Design Dialogue* by Jerry Samuelson and Jack Stoops. Davis Publications, Inc., Worcester, Massachusetts.

C

Yaacov Agam, *Beating Beating Heart,* 1978. Polished stainless steel, 9″ (23 cm) diameter. Courtesy Gallery West, Los Angeles. Photograph: Roberta Feverstein.

This pincushion was created in 1909. It was made from velvet and decorated with many tiny beads.

This metal sculpture was created by Yaacov Agam. In this view, the metal lines look like hearts.

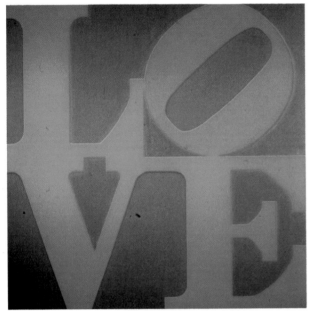

D Robert Indiana, *Love*, 1966. Acrylic on canvas, 71⅞ × 71⅞″ (183 × 183 cm). Indianapolis Museum of Art, Indiana (James E. Roberts Fund).

Some artists like to change the traditional shapes of letters or words. Robert Indiana created this painting of the word "love." Do you like to look at this painting? Why?

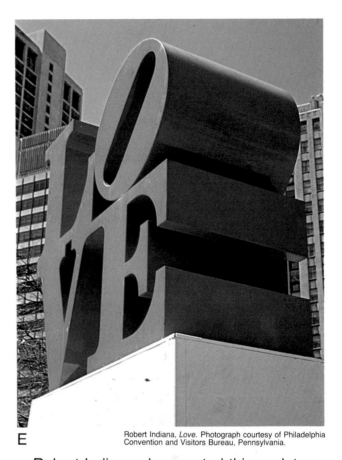

E Robert Indiana, *Love*. Photograph courtesy of Philadelphia Convention and Visitors Bureau, Pennsylvania.

Robert Indiana also created this sculpture. How is it different from his painting? He changed the traditional arrangement of letters in both works of art. What else makes his artwork original?

You can create original art by using traditional symbols in a new way. You can also invent new symbols and new kinds of art for a tradition such as Valentine's Day.

In the next lesson you will create an unusual valentine from fabric and yarn. Study the examples in the next lesson. Then draw a valentine design that you could make from fabrics and yarn or thread.

Fiber artists use thread, yarn and other long, thin materials. Some fiber artists **weave** fibers into cloth or woven pictures called tapestries.

Some fiber artists do stitchery. **Stitchery** is art created by sewing with a needle and yarn or thread. The example in picture A is a ceremonial quilt.

Stitchery can be combined with appliqué. **Appliqué** is art created by stitching cut pieces of fabric onto a cloth background.

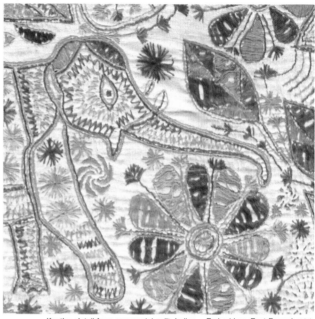

A *Kantha,* detail from ceremonial quilt. Indian, Embroidery, East Bengal, 19th century. Two layers of white cotton sari fabric, 72½ × 46¼" (194 × 117.5 cm). The Cleveland Museum of Art, Ohio (Gift of The Textile Arts Club).

Picture B shows how to put soft padding, such as cotton, between two layers of fabric. This makes fabric three-dimensional, like the soft jewelry in picture C.

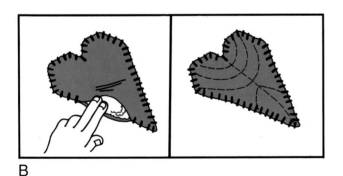

B

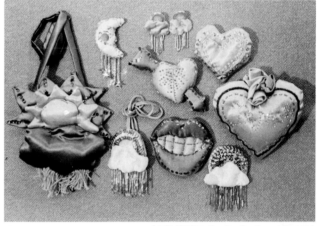

C Leslie Masters, *Jewelry.* Courtesy of the artist.

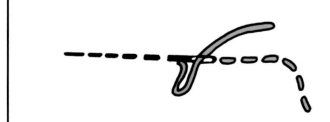

running

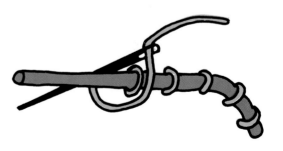

couching

E

Creative artists often use art materials in unusual ways. Claus Oldenburg created the large sculpture in picture D. The forms in his sculpture were made of fabric, then stuffed with a soft material. What else did he want you to see? What does his sculpture make you think about?

Use fabrics to create an unusual valentine or valentine gift. Stitchery, appliqué and other kinds of fiber art should be done carefully. Careful work takes time. You may want to finish your work at home.

Five kinds of stitches are shown below. You can combine them or invent variations of your own.

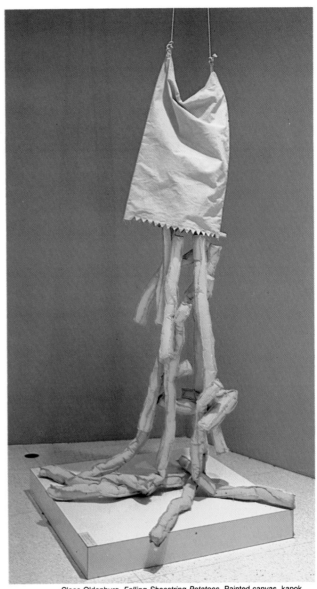

D

Claes Oldenburg, *Falling Shoestring Potatoes*. Painted canvas, kapok, 108 × 46 × 42″ (274 × 117 × 107 cm). Collection, Walker Art Center, Minneapolis, Minnesota (Gift of the T. B. Walker Foundation).

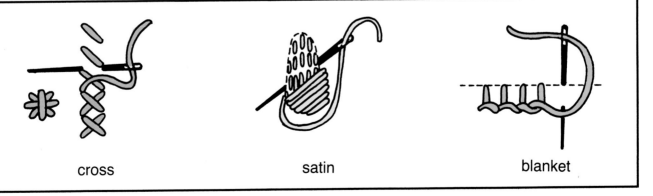

cross satin blanket

Three Famous Artists
Renaissance Art

The Middle Ages ended around 1400 A.D., when people began to live in cities and travel. A new time began, called the **Renaissance** (French for reawakening). It lasted for about 200 years.

The Renaissance began in Italy and gradually spread to the rest of Europe. Three of the most famous Italian artists were Michaelangelo, Leonardo and Raphael.

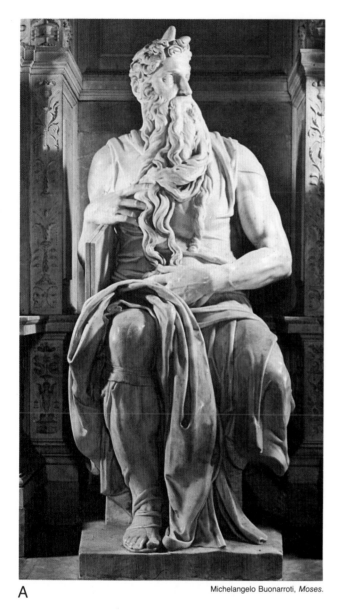

A

Michelangelo Buonarroti, *Moses*.

Michelangelo Buonarroti was a great sculptor, painter and architect. He carved many marble statues for churches and for wealthy people. He also painted murals on the ceiling of the Sistine Chapel in Rome. The murals cover a space 132 feet long and 44 feet wide (37 × 13.5 m).

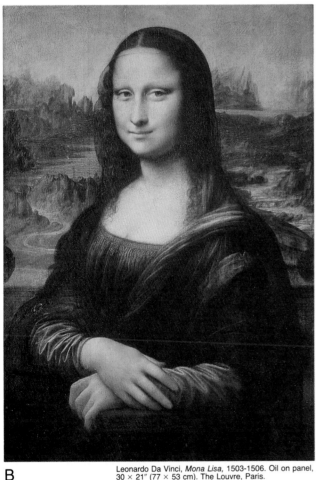

B

Leonardo Da Vinci, *Mona Lisa*, 1503-1506. Oil on panel,
30 × 21″ (77 × 53 cm). The Louvre, Paris.

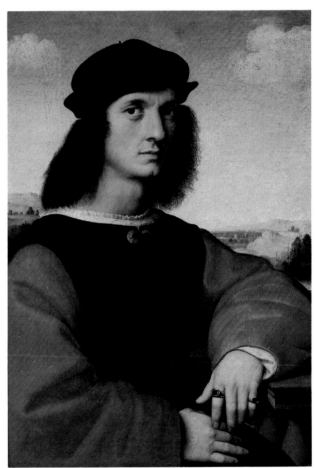

C

Raphael, *Angelo Doni*, ca. 1505. Oil on wood, 24¾ × 17¾″ (63 × 45 cm).
Uffizi, Florence, Italy. Photograph courtesy Art Resource, New York.

Leonardo da Vinci was an artist, scientist and inventor. He filled many notebooks with drawings of things he saw in nature. He drew ideas for a submarine, helicopter and parachute long before these were actually made.

One of his most famous paintings is the *Mona Lisa,* shown above. It is a portrait of an Italian woman. Many people have wondered if the artist has shown a happy or sad person. What do you think? Why?

Raphael Sanzio learned many things from Michelangelo, Leonardo and other artists of his time. How is this portrait by Raphael similar to Leonardo's *Mona Lisa*?

Artists of the Renaissance studied many different subjects. Some artists, such as Michelangelo and Leonardo, learned to do several different things very well. What are your favorite subjects? What activities do you do best? Create a drawing that shows what you do very well.

75

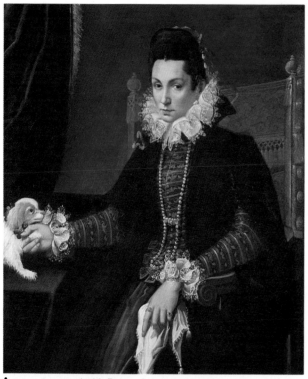

A Lavinia Fontana, *Portrait of a Noblewoman*. Italian, 16th century.
The Walters Art Gallery, Baltimore, Maryland.

Do you like to look at textures, light, shadow and small details? These design elements were very important to many Renaissance artists. Look for these design elements in Lavinia Fontana's painting. She was an Italian artist of the Renaissance.

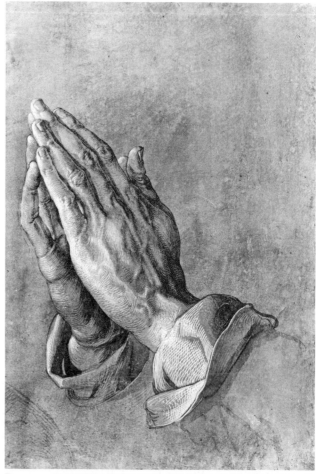

B Albrecht Durer, *Praying Hands*, 1508. Black and white chalk on blue paper.
The Albertina Museum, Vienna, Austria.

Albrecht Dürer, a German artist, liked to create pictures of many different subjects, such as plants, animals, people, myths and Bible stories. Some of his pictures were art prints. They were carved in wood or metal and covered with ink. Then many copies were printed. Many people could see or buy the same picture.

B.C. | 100 | 200 | 300 | 400 | 500 | 600 | 700 | 800 | 900 | 1000 | 1100 | 1200 | 1300 | 1400 | 1500 | 1600 | 1700 | 1800 | 1900 | 2000

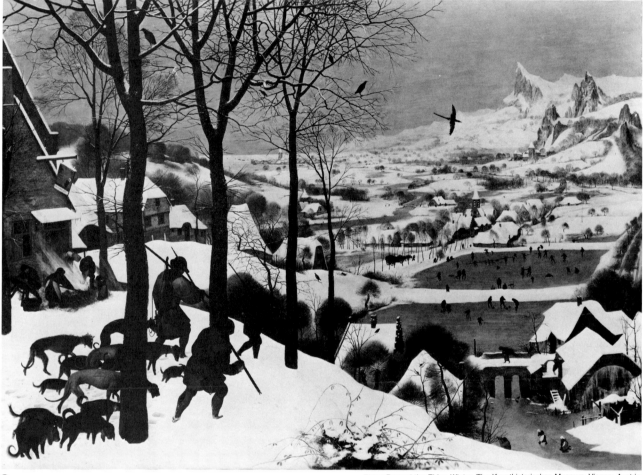

C

Pieter Breugel the Elder, *Winter*. The Kunsthistorisches Museum, Vienna, Austria.

Pieter Bruegel the Elder was a famous artist from Belgium. He was one of the first Renaissance artists to paint landscapes such as this winter scene. He painted many pictures that are filled with people and other details.

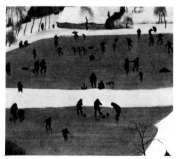

D

Look at the drawing you made in the last lesson. Try to improve it by adding textures, light and shadow or small details.

Renaissance artists discovered rules for drawing objects so they look near or far away. Here are three of their rules.

A
1. Draw the nearest objects so they overlap some objects farther away.

B
2. Draw distant objects smaller and closer to the top of the picture.

C
3. Draw guidelines toward a point. Use the guidelines to draw things smaller and smaller.

D *Viator Interior*, Toul, 1505. Woodcut. Pierpont Morgan Library, New York.

Viator, a Renaissance artist, created this woodcut of a room. What rules did he use to show objects that are near and far away? Some hints can be found in the diagram shown below.

E

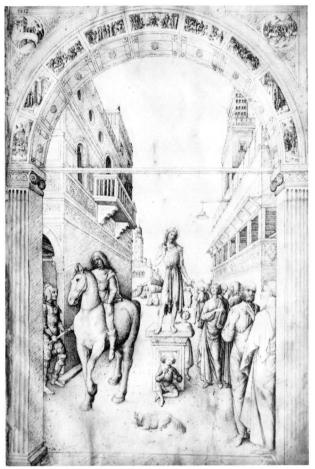

F

Jacopo Bellini, *Saint John the Baptist Preaching, ca.* 1438.
Photograph courtesy Art Resource, New York.

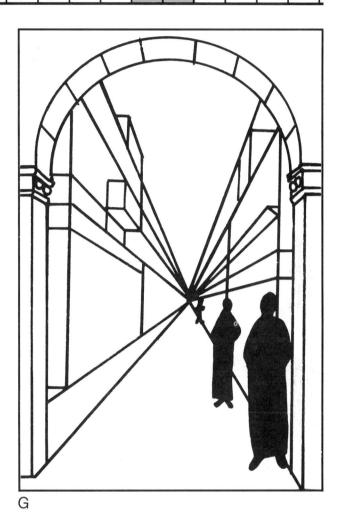

G

Jacopo Bellini, another Renaissance artist, created this drawing. Can you point to parts of the scene that he drew by following rules?

Many artists learn rules for drawing objects and scenes that show distance. The rules help them make **perspective** drawings. The rules explained here are three of the most important for perspective drawings.

Now look at your classroom or a scene outside the window. See if you can draw a picture of the scene to show distances. Observe the scene carefully and use at least one rule for perspective drawing.

79

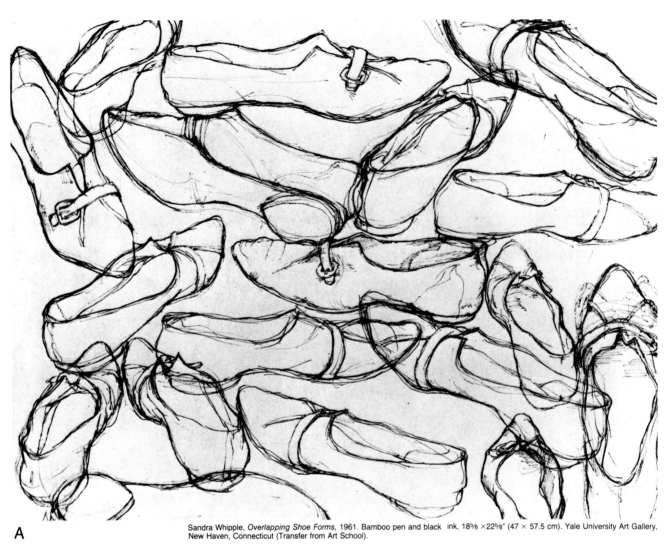

A

Sandra Whipple, *Overlapping Shoe Forms,* 1961. Bamboo pen and black ink, 18⅝ ×22⅝″ (47 × 57.5 cm). Yale University Art Gallery, New Haven, Connecticut (Transfer from Art School).

An artist drew many views of one shoe. A **view** is the position of an object when you look at it. This kind of drawing is called a study. A **study** is artwork created for practice or to try out ideas.

Many artists like to draw ordinary objects such as shoes, food, books or parts of a room. Some artists want to show how the objects have been used by people. Each object may have special marks or shapes. These can tell whether the object is old or new, cared for or abused.

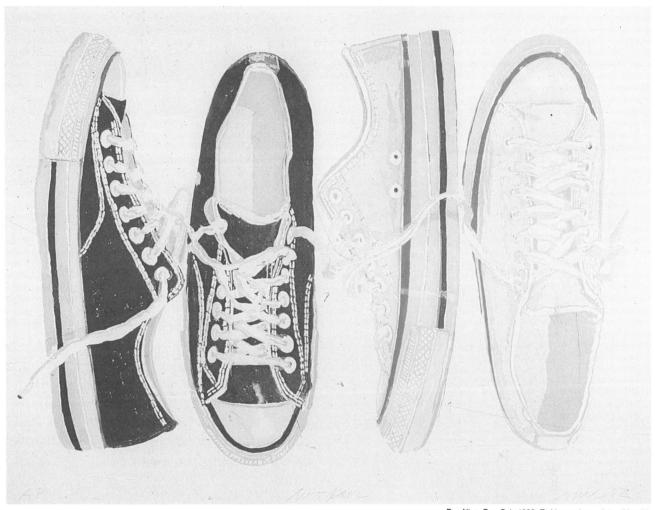

B

Don Nice, *Two Pair*, 1982. Etching and aquatint, edition 50.
Published by Pace Editions Inc.

An artist created this picture of two pairs of tennis shoes. What views of the tennis shoes did he show? If these shoes could speak, what stories might they tell?

Draw one or both of your shoes. Try to show if your shoes are old or new. Draw other details such as the stitching, scuff marks or wrinkles. Create your drawing as if you were making a portrait of your shoes.

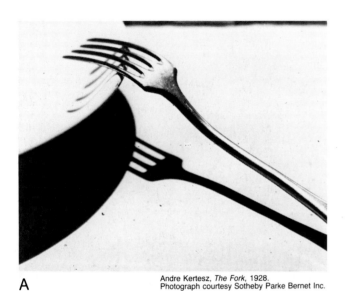

A

Andre Kertesz, *The Fork*, 1928.
Photograph courtesy Sotheby Parke Bernet Inc.

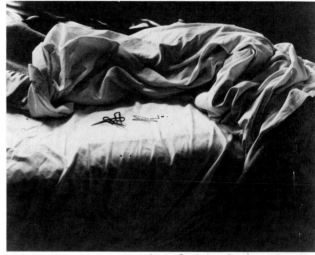

B

Imogen Cunningham, *The Unmade Bed*, 1954.
Photograph courtesy Sotheby Parke Bernet Inc.

Some artists are photographers. They use cameras to take photographs of people, places and objects.

These photographs of objects and rooms are works of art. The photographers wanted us to see ordinary things in a new way. The artists carefully decided on the parts to include in the photograph. This decision is called **framing** or **composing** the photograph.

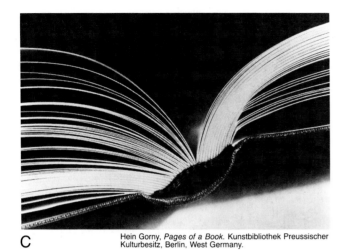

C Hein Gorny, *Pages of a Book.* Kunstbibliothek Preussischer
 Kulturbesitz, Berlin, West Germany.

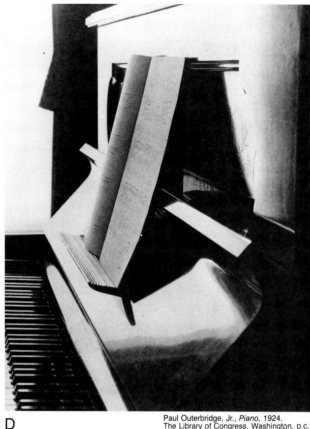

D Paul Outerbridge, Jr., *Piano,* 1924.
 The Library of Congress, Washington, D.C.

These photographs have fairly high **contrast.** In high-contrast photography the artist wants us to see the shapes, lines and textures. These are made by bright light and dark shadows. There are few shades of gray. The photographs are created to show the beauty of very light and very dark forms.

Today you will draw parts of objects or parts of your classroom. Frame or compose your drawing as if you were taking a photograph of it. Compose the drawing so it will be a work of art.

Create a high-contrast drawing. Draw the lines, shapes and textures that are very dark. Leave your paper white to show areas that are very light. In the next lesson, you will make a print of your drawing.

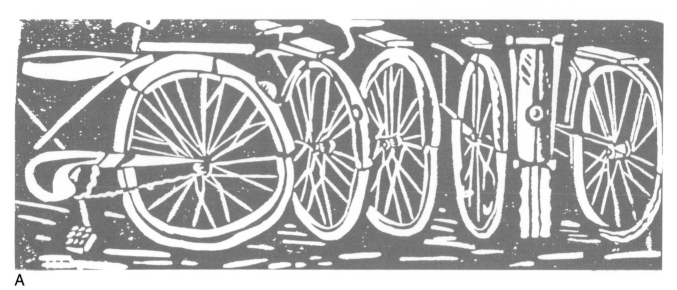

A

Artists use special tools to make **relief prints.** First they plan a design. Then they carve the design into a **block.**

Next thick ink is rolled onto the carved block. The ink misses the parts that are carved away. These areas will be white when the block is printed.

Paper is put onto the inked block. The back of the paper is rubbed. This transfers the ink onto the paper to make the print.

The design for this print of bicycles was carved into a long, narrow block. Each white line was carved out of the block. The shapes between the lines were planned very carefully.

Make some prints. Press your design into a block of Styrofoam. Then follow these steps.

D 1. Put paint or ink on your block.

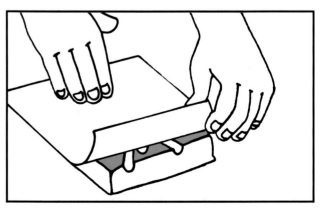

2. Place paper on top of the block.

Printmaking is a way to create many copies of a picture. Students made the art prints in this lesson.

This is a printing block made from Styrofoam. The white lines and shapes have been carved away.

B

This relief print was made from the block. Your design on the block must be reversed so your print will look right.

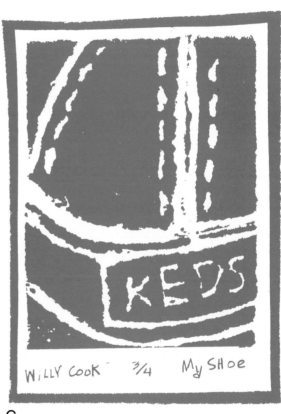

C

Keep your most successful prints. Put your name and a title on your prints.

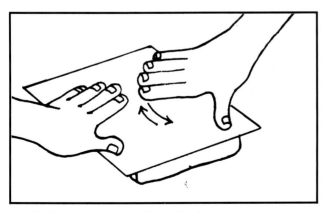

3. Hold the paper. Rub it all over.

4. Lift the paper up. Let your print dry.

Art for Royal Families
Baroque Painting

After the Renaissance, artwork in Europe became more varied. For about 200 years, artists borrowed and changed ideas from the Renaissance. The art of Europe from about 1600 to 1800 is called Baroque. **Baroque** means unusual or full of surprises.

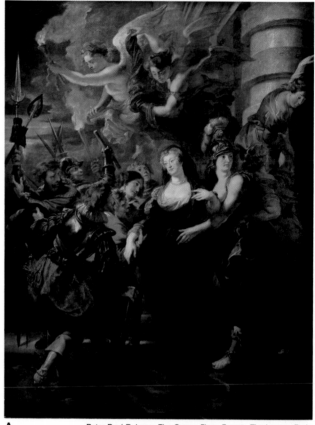

A Peter Paul Rubens, *The Queen Flees France*. The Louvre, Paris.

Peter Paul Rubens lived in Belgium. He created many paintings for royal families in Europe. Many of his paintings are large and filled with swirling motions. Look for swirling motions in his painting, *Marie Becomes Regent.*

B.C. | 100 | 200 | 300 | 400 | 500 | 600 | 700 | 800 | 900 | 1000 | 1100 | 1200 | 1300 | 1400 | 1500 | 1600 | 1700 | 1800 | 1900 | 2000

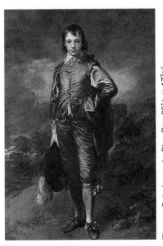

B

Thomas Gainsborough, *Blue Boy*. 26½ × 17¾" (67 × 45 cm). The Henry E. Huntington Library and Art Gallery, San Marino, California.

In England, Thomas Gainsborough became famous for his paintings of aristocrats. This is a well known example of his art. It is often called *Blue Boy.*

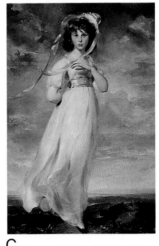

C

Thomas Lawrence, *Pinkie*. 23⅞ × 16¼" (60 × 41 cm). The Henry E. Huntington Library and Art Gallery, San Marino, California.

Thomas Lawrence was also a famous English painter. This painting, often called *Pinky*, is as well-known as *Blue Boy.* Why do you think the two paintings are so famous?

For 38 years, Diego Velazquez lived and worked in the palace of a Spanish king and queen. He painted many portraits of the royal family. How did Velazquez help you see that his painting shows a young prince?

Many Baroque paintings have graceful or swirling curves like the letters **S** or **C**. Draw some **S** or **C** curves on paper. Can you change the curves into a graceful or action-filled picture?

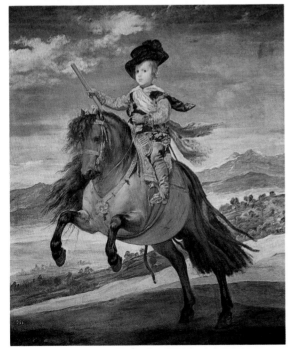

D

Diego Velazquez, *Prince Balthazar-Carlos on a Pony.* 19¼ × 16" (49 × 41 cm). Museo del Prado, Madrid, Spain.

E

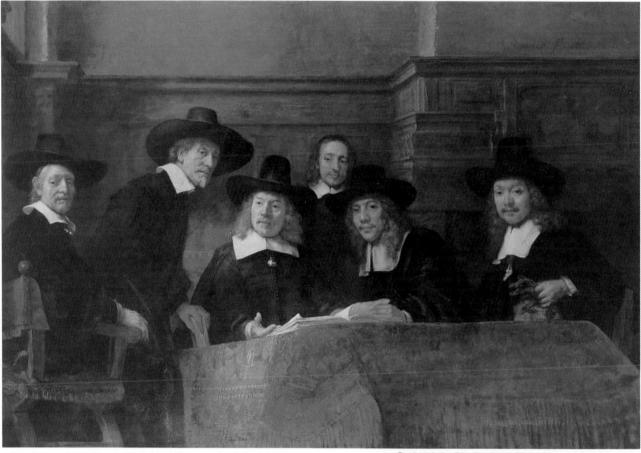

A

Rembrandt Van Rijn, *The Syndics of the Cloth Guild*, 1662.
Oil on canvas, 74½ × 109″ (191 × 279 cm). Rijksmuseum, Amsterdam.

Between 1600 and 1800, Holland became an important place for artists. The Dutch people were merchants and traders. Many people had money to spend for art. The artists in Holland could create art for homes, businesses or city buildings, as well as for royalty and the church.

Rembrandt van Rijn was one of the most famous portrait painters in Holland. He painted this group portrait of people who were in charge of a union. Each person helped to pay for the portrait. Rembrandt used very light colors to show the faces.

Rembrandt painted this picture more than 300 years ago, in 1662. The men's clothes are similar to the clothes the pilgrims wore to America. Can you explain why?

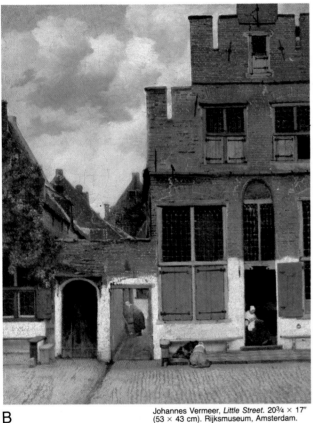

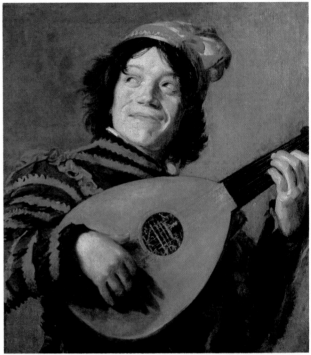

B

Johannes Vermeer, *Little Street.* 20¾ × 17″
(53 × 43 cm). Rijksmuseum, Amsterdam.

Johannes Vermeer was another Dutch artist. He became famous for scenes that show everyday life. He also liked to paint pictures of people inside their homes.

Many artists in Holland studied artwork from the Renaissance. The most successful Dutch artists became experts in showing light, shadow, textures and details.

C

Judith Leyster, *The Jester.* 22 × 19¼″
(56 × 49 cm). Rijksmuseum, Amsterdam.

Judith Leyster created this painting of a jester. A jester is a kind of clown. What parts of her painting tell you that this is a jester?

Paintings of this kind were very popular in Holland. People liked to see pictures of other people who were having fun.

Artists in Holland painted many different subjects. They painted portraits, landscapes, cityscapes, flowers and scenes inside homes.

Choose a subject to draw. Try to draw it so someone might like to display it at home or in another building in your town.

89

Animals and People in Art
Different Styles of Art

Between 1800 and 1900, artists in Europe created many different styles of art. **Style** is what helps you see differences in the works artists create.

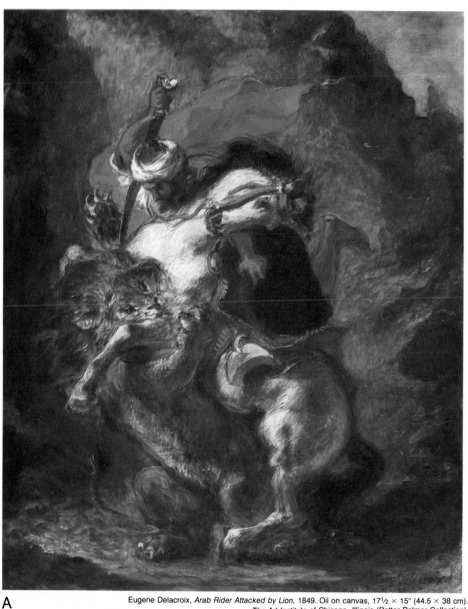

A

Eugene Delacroix, *Arab Rider Attacked by Lion,* 1849. Oil on canvas, 17½ × 15″ (44.5 × 38 cm). The Art Institute of Chicago, Illinois (Potter Palmer Collection).

This style of painting is called **Romantic.** Romantic art often tells about adventures in far away places or surprising events in nature. Eugène Delacroix created action-filled paintings like this one from sketches that he made in zoos and in Africa.

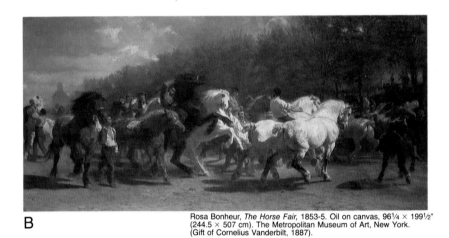

B

Rosa Bonheur, *The Horse Fair*, 1853-5. Oil on canvas, 96¼ × 199½"
(244.5 × 507 cm). The Metropolitan Museum of Art, New York.
(Gift of Cornelius Vanderbilt, 1887).

The style of Rosa Bonheur's painting is known as **Realism.** Realistic art looks like something you might see and photograph. Rosa Bonheur learned to create realistic art by sketching animals and studying their anatomy.

Henri de Toulouse-Lautrec worked in a style called **Impressionism.** An impression is something you see quickly, like the main colors or shapes of objects. Impressionist painters try to record what they see very quickly.

Draw your favorite animal. Give your drawing a special style. How will your style of drawing differ from the styles of other students?

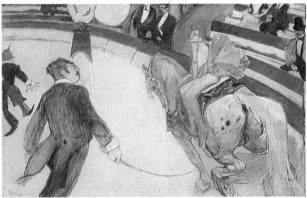

C Henri de Toulouse-Lautrec, *In The Circus Fernando: The Ring Master*, 1888.
Oil on canvas, 38¾ × 63½" (98.5 × 161 cm). The Art Institute of Chicago, Illinois
(Joseph Winterbotham Collection).

Some of the first photographs of moving animals were taken around 1870 by Eadweard Muybridge. How are the photographs different from the artworks in pictures A, B and C.

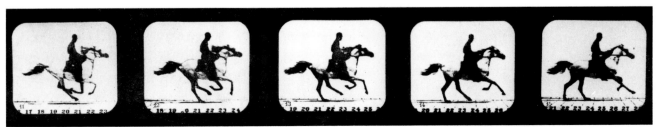

D

Eadweard Muybridge, *Mohammed-Running*. Photograph.

Painting
Mixing Tints and Shades

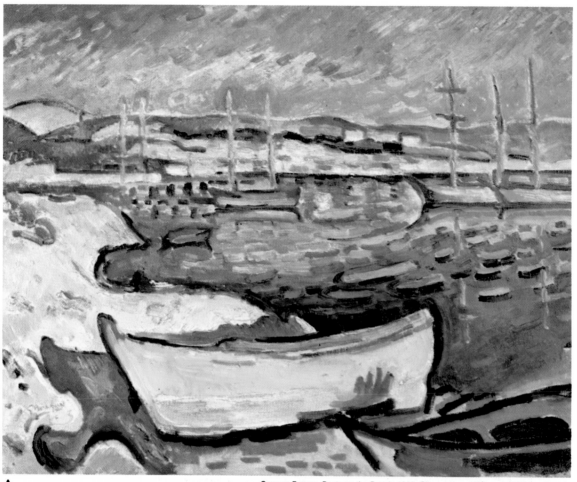

A

Georges Braque, *Boats on the Beach*, 1906. Oil on canvas, 19½ × 27½" (50 × ·70 cm). Los Angeles County Museum of Art, California (Gift of Anatole Litvak).

Artists use light and dark colors in their pictures. The lightness or darkness of a color is called its **value.** Light values of a color are called **tints.**

What tints do you see in this painting by Georges Braque? Can you also find very intense, bright colors? Notice how the artist used a brush to apply patches of color.

Learn to mix tints. Begin with white paint. Add dots of color. Mix the paint. What happens when you add more color to the white paint?

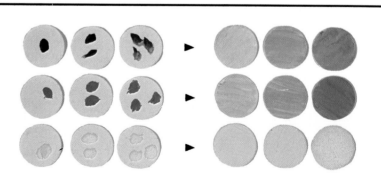

B

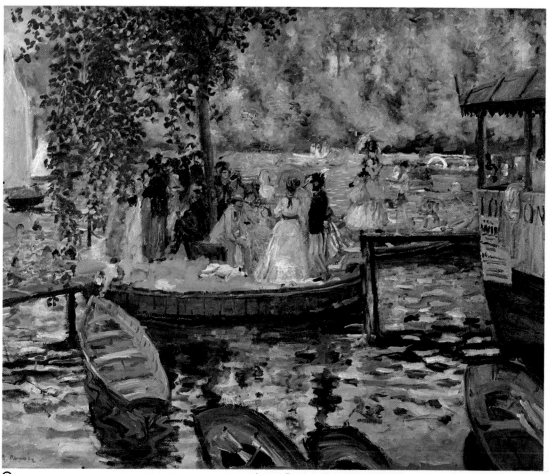

C

Auguste Renoir, *La Grenouillere*, 1869. Oil on canvas, 25¾ × 31½" (66 × 81 cm). Nationalmuseum, Stockholm.

Auguste Renoir, like many other artists of his time, created paintings in the Impressionist style. His painting is dominated by dark values. Dark values of a color are **shades.**

Shading is a gradual change from light to dark values. Contrast is a big, easily-seen difference in values. Find parts of Renoir's painting that have shading and contrast.

Learn to mix shades. Begin with a color. Add dots of black to the color. Mix the paint. What happens when you add more black to the color?

D

45

Painting
New Ways of Painting

When photography was invented about 150 years ago, artists began to experiment with new ways of painting. They wanted to create paintings that were very different from photographs.

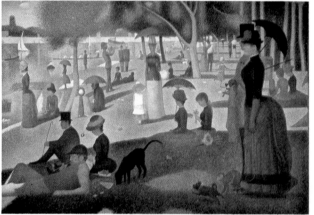

A Georges Seurat, *Sunday Afternoon on the Island of La Grande Jatte*, 1884-86. Oil on canvas, 81 × 120⅜" (206 × 306 cm). The Art Institute of Chicago, Illinois (Helen Birch Bartlett Memorial Collection).

Georges Seurat used many dots of color side by side on his paintings. When the dots of color are seen from a distance, the colors seem to blend together.

B *Sunday Afternoon on the Island of La Grande Jatte* (detail).

Seurat's brushstrokes

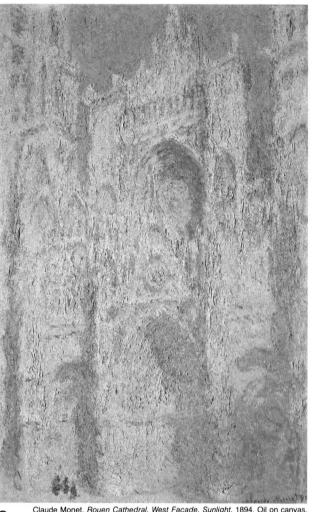

C Claude Monet, *Rouen Cathedral, West Facade, Sunlight*, 1894. Oil on canvas, 39½ × 26" (100 × 66 cm). National Gallery of Art, Washington, D.C. (Chester Dale Collection 1962).

Claude Monet liked to take his paints and brushes outside. Many of his paintings show us how the colors of objects change from morning to evening. He created this painting of a cathedral at sunset. The shadows are dabs of orange and blue paint.

D *Rouen Cathedral, West Facade, Sunlight* (detail).

Monet's brushstrokes

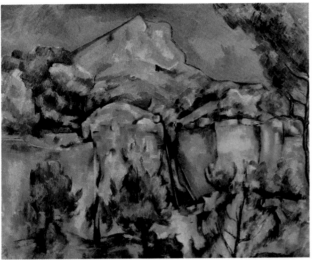

E

Paul Cezanne, *Mont Sainte Victoire*, 1898-1900. Oil on canvas, 25½ × 32″ (65 × 81 cm). Baltimore Museum of Art, Maryland (The Cone Collection).

Paul Cezanne's paintings have many flat patches of color. He changed the direction and the color of each brushstroke to create the illusion of forms. He said that everything in nature could be painted as if it were part of a cube, a cylinder or sphere.

Mont Sainte Victoire (detail).

F

Cezanne's brushstrokes

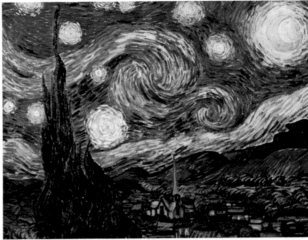

G Vincent Van Gogh, *The Starry Night*, 1889. Oil on canvas, 29 × 36¼″ (74 × 92 cm). The Museum of Modern Art, New York (Acquired through the Lillie P. Bliss Bequest).

Vincent Van Gogh wanted to show that energy and motion are present in everything we see. He often used very intense colors and swirling brushstrokes to express his ideas and feelings.

The Starry Night (detail).

H

Van Gogh's brushstrokes

Use paint colors and brushstrokes in a new or special way. Create a painting that is very different from other paintings you have made.

95

Modern Art
New Styles of Art

Around 1900, everyday life in Europe and North America began to change very quickly. Many changes came from new machines and inventions such as telephones, automobiles and airplanes. These changes were the beginning of the Modern Age.

Modern art is very much like modern life. Artists have invented many new ways to create paintings, sculpture and other kinds of art.

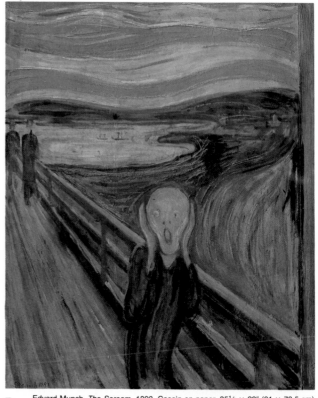

B Edvard Munch, *The Scream*, 1893. Casein on paper, 35½ × 29″ (91 × 73.5 cm). Nasjonalgalleriet, Oslo.

Pablo Picasso was one of the most inventive artists in modern times. One of his paintings is shown below. His painting is an example of a new style of art called **Abstraction.** Artists create abstract art by using unusual lines, shapes or patterns to show things they see or remember.

Expressionism is another style of modern art. In this kind of artwork, the artist expresses ideas about joy, sorrow, anger or other feelings. Edvard Munch's painting is an example of this style.

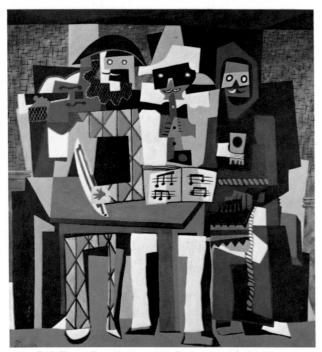

A Pablo Picasso, *Three Musicians*, 1921. Oil on canvas, 80 × 74″ (203 × 188 cm). Philadelphia Museum of Art, Pennsylvania (A. E. Gallatin Collection).

B.C. 100 200 300 400 500 600 700 800 900 1000 1100 1200 1300 1400 1500 1600 1700 1800 1900 2000

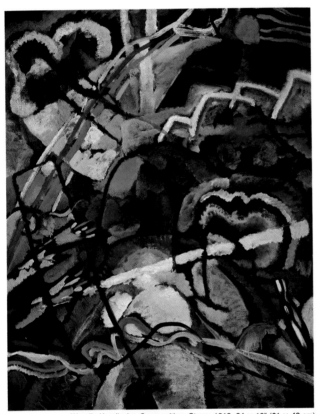

C

Wassily Kandinsky, *Composition: Storm,* 1913. 24 × 19″ (61 × 48 cm). Phillips Collection, Washington, D.C.

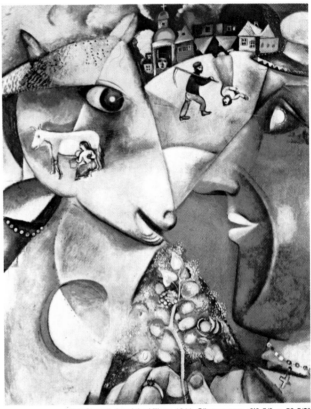

E

Marc Chagall, *I and the Village,* 1911. Oil on canvas, 6′3 5/8 × 59 5/8″ (192 × 151 cm). Collection, The Museum of Modern Art, New York (Mrs. Simon Guggenheim Fund).

Pictures C and D are examples of **Nonobjective** art. The paintings do not show objects or other recognizable things. Piet Mondrian and Wassily Kandinsky believed that ideas and feelings could be expressed by using only lines, colors and shapes.

Marc Chagall and many other artists have tried to show dreams and imaginary places. This style of art is called **Fantasy Art.** What parts of this painting are dreamlike?

Choose one of the styles of art in this lesson. Keep your choice a secret. Create an original drawing so the class can guess the style you selected.

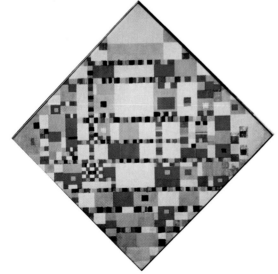

D

Piet Mondrian, *Broadway Boogie Woogie,* 1942-43. Oil on canvas, 50 × 50″ (127 × 127 cm). Collection, The Museum of Modern Art, New York (Given anonymously).

Creating A Collage
Abstract Art

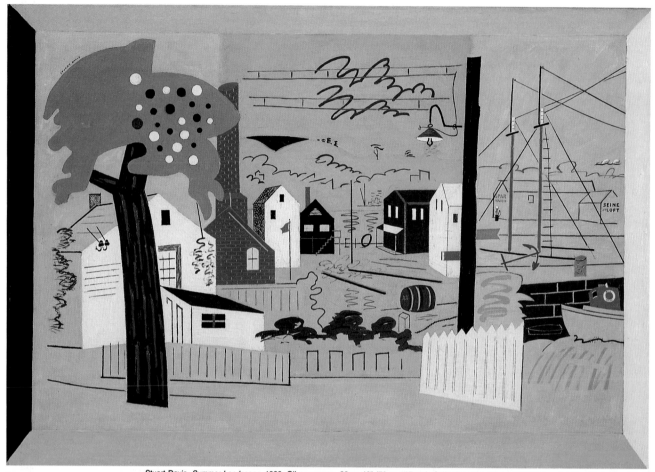

A

Stuart Davis, *Summer Landscape*, 1930. Oil on canvas, 29 × 42" (79 × 107 cm). Collection, The Museum of Modern Art, New York (Purchase).

Some artists create abstract art. Abstract means the artist changes things that he or she has seen. The artist invents new lines, shapes and colors instead of trying to show a scene that looks real.

Stuart Davis, a famous American artist, created this abstract painting. He invented lines, shapes and colors to make parts of his painting more interesting and lively than the real scene.

B

Photograph of subject used by Stuart Davis in his *Summer Landscape,* 1930. Courtesy The Museum of Modern Art, New York.

This is a photograph of the scene that Stuart Davis saw and abstracted. What parts of the real scene did he include in his painting? How did he change these parts?

What parts of the real scene did he leave out of the painting? Can you find other differences between the photograph and the painting?

Find a photograph or look at part of your classroom. Cut some paper shapes similar to the shapes you see, but change the color, size or edges.

Paste down your paper shapes. Use crayons to add other lines, shapes, colors or textures. Your artwork will be a collage. A **collage** is artwork made by pasting down paper, cloth or other materials.

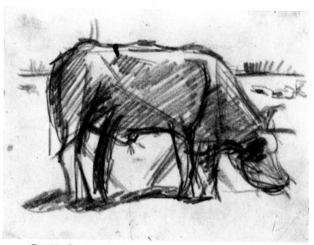

A Theo Van Doesburg, *The Cow,* undated. From a series of eight pencil drawings, 4⅝ × 6¼″ (12 × 16 cm). Collection, The Museum of Modern Art, New York (Purchase Fund).

Abstract art is created by changing the lines, shapes or colors of something you see or remember.

Picture A shows a drawing of the main shapes of a cow. The artist shaded some of the shapes to suggest the form of a real cow. The drawing is realistic.

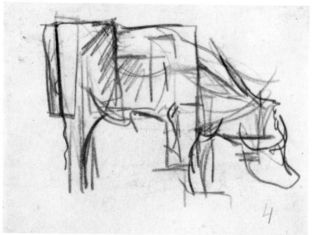

B Theo Van Doesburg, *The Cow,* undated. From a series of eight pencil drawings, 4⅝ × 6¼″ (12 × 16 cm). Collection, The Museum of Modern Art, New York (Purchase Fund).

Compare this drawing with the first one in picture A. Many of the curved lines in picture A have been changed to straight lines in picture B. Can you find other changes?

In picture C, the artist has changed some of the lines into shapes. Some of the shapes are filled in to make a flat pattern of light and dark shapes.

C Theo Van Doesburg, *The Cow,* undated. From a series of eight pencil drawings, 4⅝ × 6¼″ (12 × 16 cm). Collection, The Museum of Modern Art, New York (Purchase Fund).

You can learn to create abstract art. Begin with a realistic sketch. Put thin paper over your sketch. Draw the same idea but change some of the lines, shapes or colors. Make several different drawings if you can.

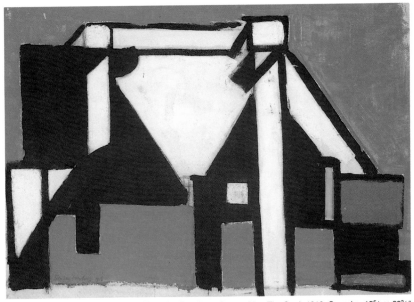

D

Theo Van Doesburg, *Composition (The Cow)*, 1916. Gouache, 15⅝ × 22¾″ (40 × 58 cm). Collection, The Museum of Modern Art, New York (Purchase).

To create the painting shown in picture D, the artist used many ideas from the sketch in picture C. Can you find the similarities?

Now look at the next painting, shown in E. The artist invented this painting by changing the main shapes into squares and rectangles. What else has been changed?

All five of these artworks were created by Theo Van Doesburg, a Dutch artist. He created the sketches and paintings to teach people how abstract art is created. He wanted people to understand how abstract paintings could come from ideas and scenes in nature.

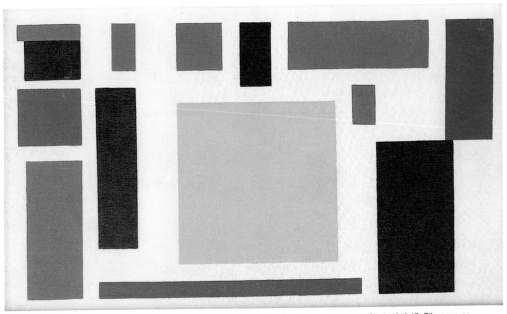

E

Theo Van Doesburg, *Composition (The Cow)*, 1916-17. Oil on canvas, 14¾ × 25″ (37.5 × 63.5 cm). Collection, The Museum of Modern Art, New York (Purchase).

Printmaking
Abstract Relief Prints

A Joseph Albers, *Aquarium*, 1934. Woodcut, 7⅛ × 10¼″ (18 × 26 cm). Philadelphia Museum of Art, Pennsylvania (Print Club Permanent Collection).

B Peter Sager, *Ice Floes No. 4*. Woodcut. Philadelphia Museum of Art, Pennsylvania (Print Club Permanent Collection).

Today you will create a relief print just as you did in Lesson 40. The print in picture A was created by an artist. The curved lines and shapes are like the motions of swimming fish. The print was made from a design carved in a block of wood. What shapes were printed with ink?

The design for this print was carved into wood. The long white shapes have smooth curves, like an iceberg. The black background is like a dark ocean. What parts of this artwork were created by carving into the wood?

Carve or press your design into a block of Styrofoam. Then, follow these steps.

1. Put paint or ink on your block.

2. Place paper on top of the block.

E

102

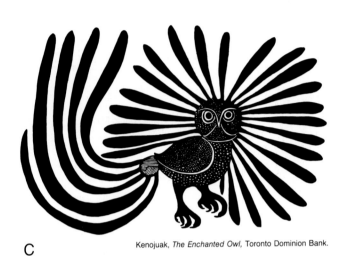

C

Kenojuak, *The Enchanted Owl,* Toronto Dominion Bank.

The design for this print was carved into a very smooth piece of stone. An Eskimo artist created the print. What makes this design an example of abstract art? What parts of the design were printed with ink? Why is the space around the bird white?

D

Walter Dexel, *Abstraction.* Woodcut, 9½ × 6″ (24 × 15 cm). Norton Simon Museum of Art at Pasadena, California (Blue Four Galka Scheyer Collection).

The artist who created this print carved the design into a block of wood. He carved away all the shapes that look white.

Make a print of your abstract design. Remember to reverse your design so it will look right in the final print.

To reverse your design, place the drawing face down on the block. Trace the design. Press firmly so the design transfers onto the block. Carve away the lines, shapes and textures that you want to be white in the final print.

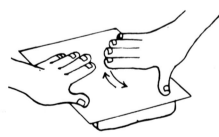

3. Hold the paper.
 Rub it all over.

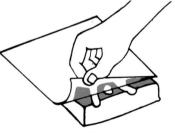

4. Carefully lift the paper.
 Let your print dry.

Keep your best prints. Put your name and a title on your prints. Prints look better if they are mounted.

Drawing
People in Action

There are many ways to create art and learn about art. Many artists practice drawing people so they can include people in their artwork. Today you will practice drawing "skeleton" people just as some artists do.

Your skeleton drawings should be very simple. The lines of the arms, legs and backbone are drawn first because these lines show how the body bends.

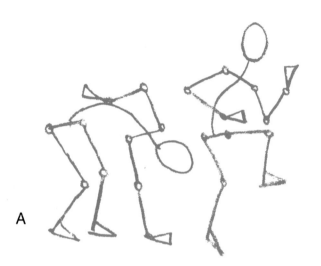

A

You can draw triangles for the hands and feet. The head is an oval. Artists often draw skeleton people like these. Then artists use their sketches to help them create other artwork.

B

You can draw people who are running, dancing and playing sports. You can learn to show how parts of the human body move.

Students your age drew this ballet dancer and football player.

C

Chris

Your arms bend at the wrist, elbow and shoulder. You can draw dots to show these joints. Draw the lines or bones about the same length.

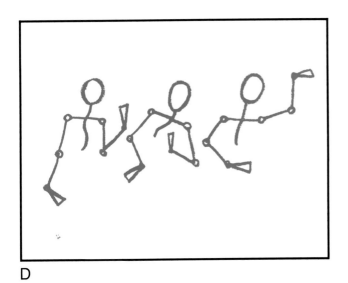

D

Make some skeleton drawings. Pick out your best ones and try to improve them.

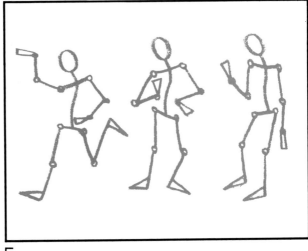

E

Your backbone and neck curve when you bend. Show the curve in your drawing. Use straight or diagonal lines to show action in the rest of the body.

Your legs bend at the ankle, knee and hip. Draw a short line for the hip. Draw the two main bones in each leg. The leg bones are about the same length.

F

Drawing in Flip Books
The Illusion of Motion

An illusion of motion is created when you see many separate pictures very quickly, one after the other. When you watch movies or television, you are seeing about twenty-four separate pictures each second!

Today you will make a flip book. A flip book is a small book with a drawing on each right-hand page. When you flip the pages quickly, the separate drawings create the illusion of movement.

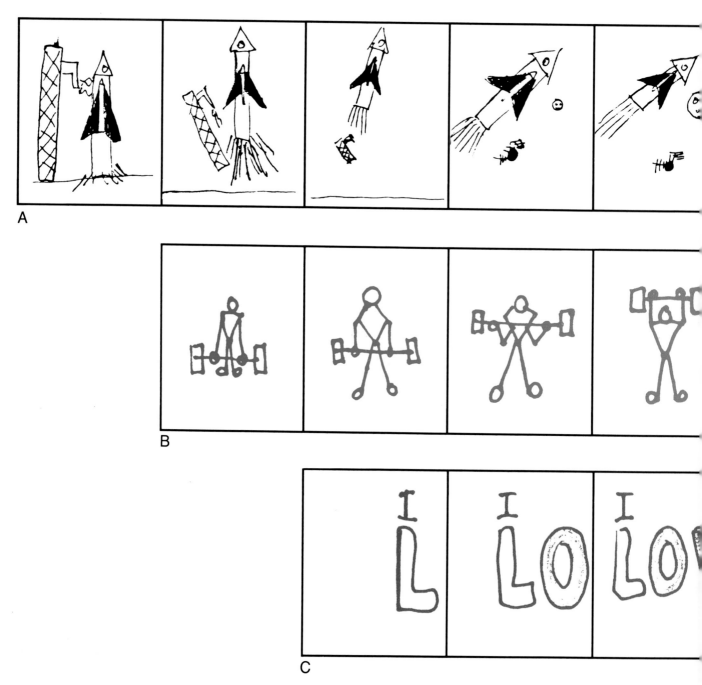

A

B

C

Students your age made the flip books shown here. The books have been taken apart so you can see the drawings on each right-hand page.

Your flip book can create the illusion of motion. Study these examples. Think of something else that moves.

Create a flip book with six or eight pages. Draw a picture on each page. Change the position and size of the objects in each drawing.

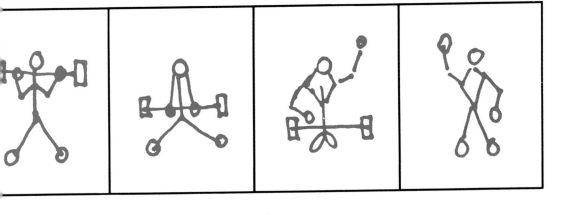

Lines and Spaces
Wire Sculpture

Alexander Calder liked to create art from wire and sheets of metal. He invented a new kind of sculpture called a **mobile.** Mobiles can move. One of his mobiles is shown below.

A mobile usually hangs from the ceiling. Each part is carefully balanced so the parts can move freely. Each part of this mobile turns slowly when the air moves.

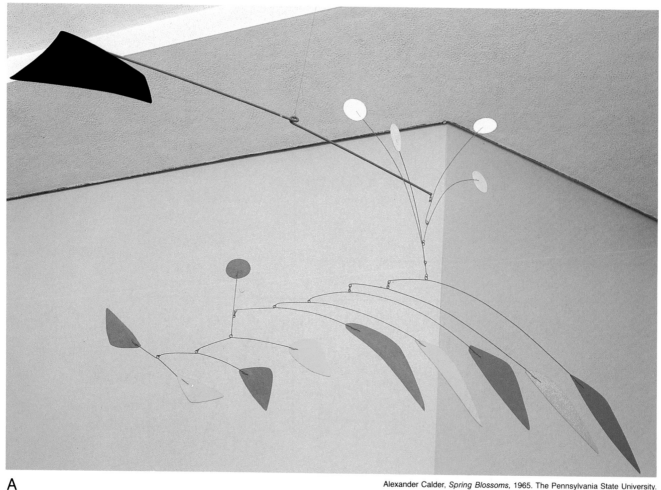

A

Alexander Calder, *Spring Blossoms*, 1965. The Pennsylvania State University.

Alexander Calder also created wire sculptures such as this *Sow.* This wire sculpture is **three-dimensional.** It has height, width and depth. The wire forms are not flat.

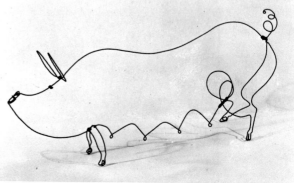

B Alexander Calder, *Sow*, 1928. Wire construction, 7 1/2 × 17" (19 × 43 cm). Collection, The Museum of Modern Art, New York (Gift of the artist).

A student created this wire sculpture of a dog. The wire was coiled over a pencil to create the body.

You can see open spaces between the wire lines and around the dog. Artists call these open spaces **voids** or **negative spaces.** Artists plan negative spaces very carefully. Can you explain why?

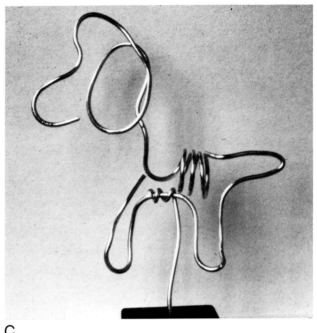

C

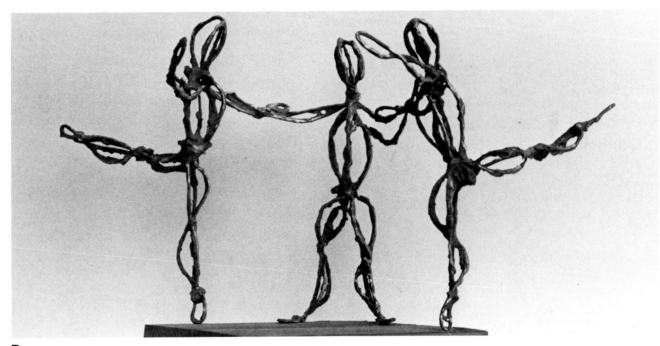

D

A student created this wire sculpture. He began with a loop of wire for each head. The loop was in the center of the length of wire. Do you see why?

Make a wire sculpture. Make your wire forms three-dimensional. Bend the wire so it curves and twists through space. Study the sculpture's lines and its negative spaces from all sides.

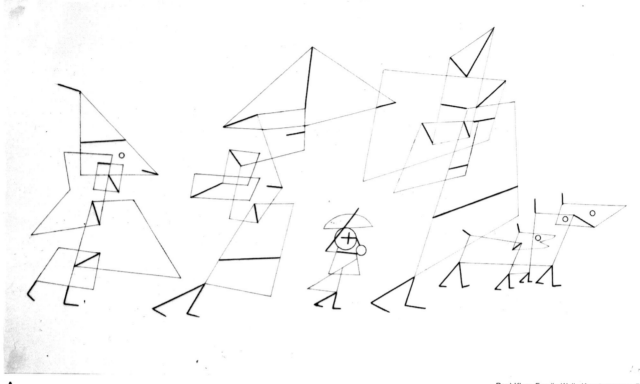

A

Paul Klee, *Family Walk*. Kunstmuseum, Bern.

This drawing was created by Paul Klee. Drawings are **two-dimensional.** The lines are drawn on flat paper. What kinds of lines do you see here?

Look for curved and straight lines. Look for thick and thin lines. What shapes do the lines create? What else did the artist want you to see?

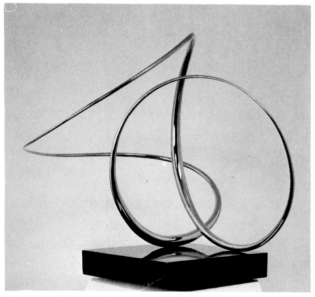

B Jose de Rivera, *Homage to the World of Minkowski*. Chrome, nickel and stainless steel, 14⅞ × 21½″ (38 × 32 cm). The Metropolitan Museum of Art, New York (Fletcher Fund, 1955).

José de Rivera created this **three-dimensional** sculpture. It is not flat. The polished metal line curves gracefully in a continuous path. The round metal rod changes gradually from a thick to a thin line. The artist carefully planned the shape of the negative spaces.

Alexander Calder created this wire sculpture. This photograph shows one view of the sculpture.

If you looked at the real sculpture, you could see other views, such as the front view and top view. Each view would look different. Do you think some views might look better than others? Why?

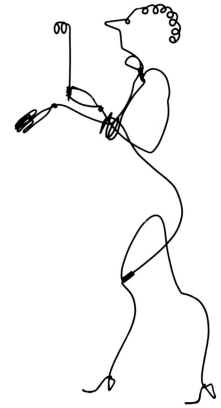

C Alexander Calder, *The Hostess*, 1928. Wire construction, 11½″ high (292 cm). Collection, The Museum of Modern Art, New York (Gift of Edward M. M. Warburg).

Lines can be two-dimensional or three-dimensional. Two-dimensional lines make flat shapes. Three-dimensional lines curve and twist through space.

D

Gebruder Thonet, *Rocking Chair*, 1860. Bent beechwood and cane, 37 1/2″ (95 cm) high. Collection, The Museum of Modern Art, New York (Gift of Cafe Nicholson).

The curved lines in this chair were planned by an industrial designer. The seat and rockers are connected by a spiral. A spiral is a line that curves around itself. In a spiral, the spaces between the curves gradually change.

Today you will draw the wire sculpture you made. Draw it from your favorite view. Try to draw lines that twist, turn and loop on paper the way the lines in your sculpture twist and loop in space.

Architecture
A Futuristic City

Some architects think about the future. They make drawings and models to show how people might live in the future.

Sometimes futuristic ideas really come true. This building is in Tokyo, Japan. Each "box" in the tower is a house, built in a factory. A crane moves and lifts the box-like houses. Each house is then plugged into a tower that provides water, electricity and an elevator.

Would you like to live in a city where stores, houses and other buildings could be moved around and "plugged" into towers?

Buckminster Fuller's model shows an imaginary city that could float. The city would have apartments for about five thousand people. The city would have stores and other things people might need.

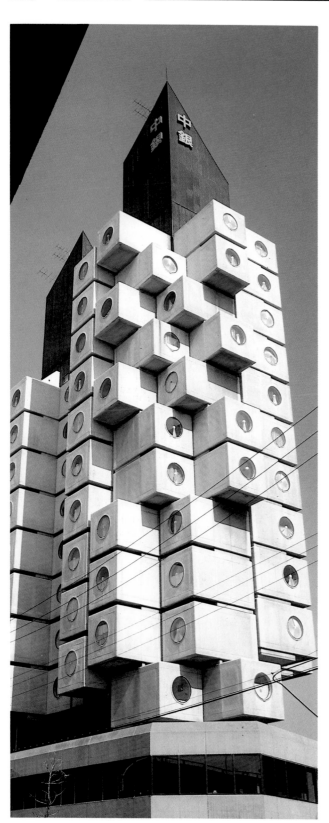

A

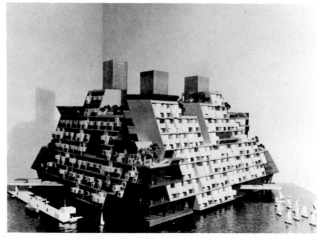

B Buckminster Fuller, *Triton City*. Model. Photo courtesy of Buckminster Fuller Institute, Los Angeles, California.

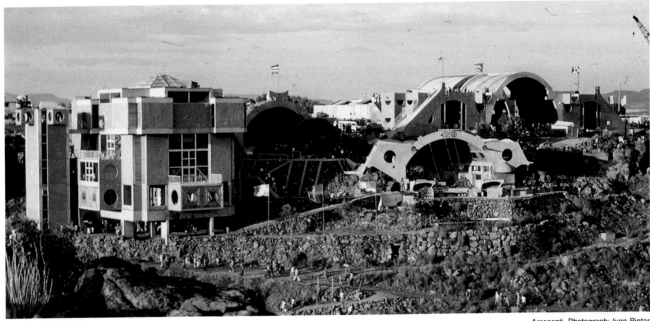

C

Paolo Soleri has designed many imaginary cities. He tries to plan cities that help people live in harmony with each other and with nature.

This is a photograph of a real city that Paolo Soleri started building in 1964. The city, called Arcosanti, is near Cordes Junction, Arizona.

Architect Victor Gruen made this trick photograph of the earth covered with cities and freeways. He does not want to see this happen. Do you?

Victor Gruen is famous for redesigning the center of old cities. He has designed new centers for Fort Worth, Texas; Newark, New Jersey; and Fresno, California.

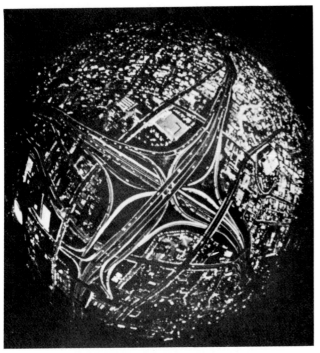

D Figure 4-4 from *Centers for the Urban Environment: Survival of the Cities* by Victor Gruen. Copyright © 1973 by Van Nostrand Reinhold. All rights reserved.

Draw your own idea of a future city. It could be a good or a bad place to live. It could be a city in outer space, or under the sea or on the earth. Use your imagination!

A

Joseph Cornell, *Soap Bubble Set*, 1936. Assemblage box, Courtesy Wadsworth Atheneum, Hartford, Connecticut.

This kind of sculpture is called an **assemblage.** The artist, Joseph Cornell, selected objects that he liked to see and think about. He arranged them in a box. What objects did he select? How did he arrange them?

Joseph Cornell wanted people to see and think about the objects he assembled. Can you find similarities in the shapes or purpose of the objects? Do some objects remind you of one main idea or theme?

Artist George Brecht built a tall cabinet for some of the objects he liked to see and think about. Some of the objects have a similar form or shape. All of the objects have special meanings to the artist.

You can make an assemblage in a box, using objects people have discarded. You may wish to trade some of your objects so each assemblage can be unified.

An assemblage can be **unified** in many ways. Unity means that all the objects look as though they belong together. They can be similar in color, size, shape or form. They can have a similar meaning or use. They might be made from similar materials.

Glue the objects inside your box so they will not fall out. Design your assemblage so the box can be displayed as a three-dimensional collage.

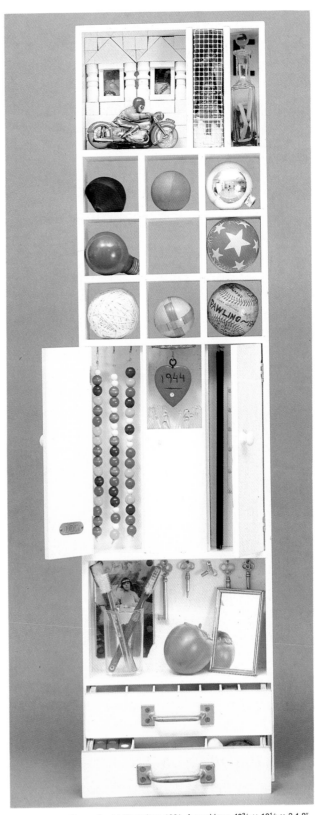

B

George Brecht, *Repository*, 1961. Assemblage, 40⅜ × 10½ × 3 1.8″ (102.5 × 27 × 8 cm). Collection, The Museum of Modern Art, New York (Larry Aldrich Foundation Fund).

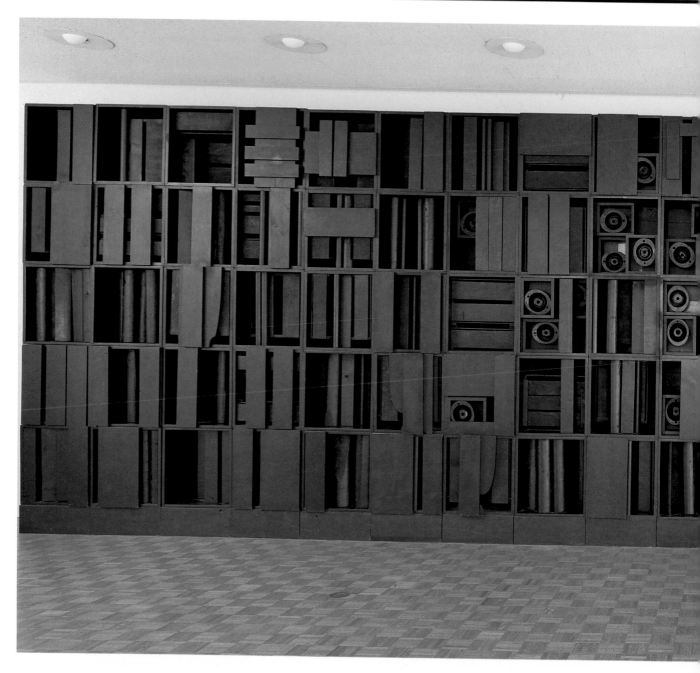

An American artist, Louise Nevelson, created this assemblage titled *Homage to the World. Homage* means respect or admiration. The sculpture was made by nailing and gluing wood inside boxes, then joining all the boxes together.

Homage to the World is a good example of two important ideas in art: unity and variety. **Unity** means that all the parts of an artwork look as though they belong together. **Variety** means that some parts are different from others.

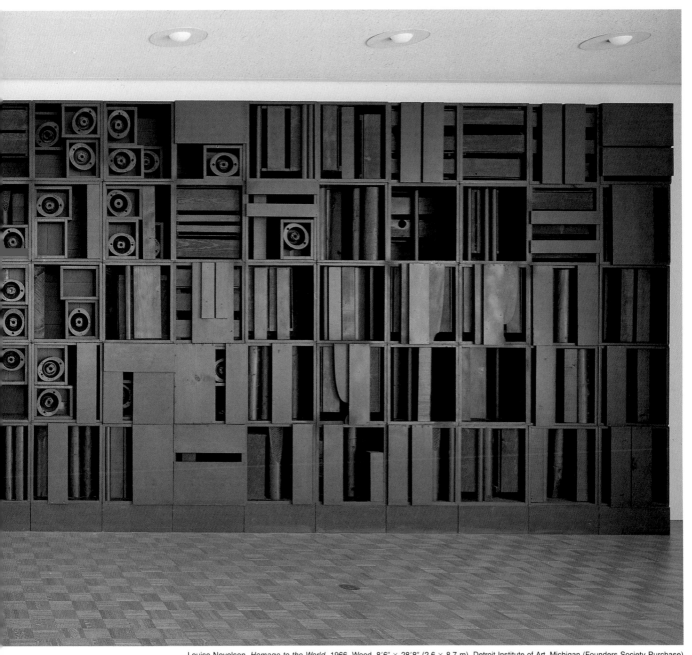

Louise Nelson, *Homage to the World*, 1966. Wood, 8′6″ × 28′8″ (2.6 × 8.7 m). Detroit Institute of Art, Michigan (Founders Society Purchase).

Unity and variety are art principles. Unity makes a work of art pleasant to see. Variety makes a work of art interesting to look at many times.

How did Louise Nevelson unify her assemblage? How did she create variety?

Look for similarities in the assemblages your class has made. See how many boxes you can display together so they look like a larger unified assemblage. Create several large sculptures if you can. Perhaps you can arrange all the boxes to make one very large unified assemblage.

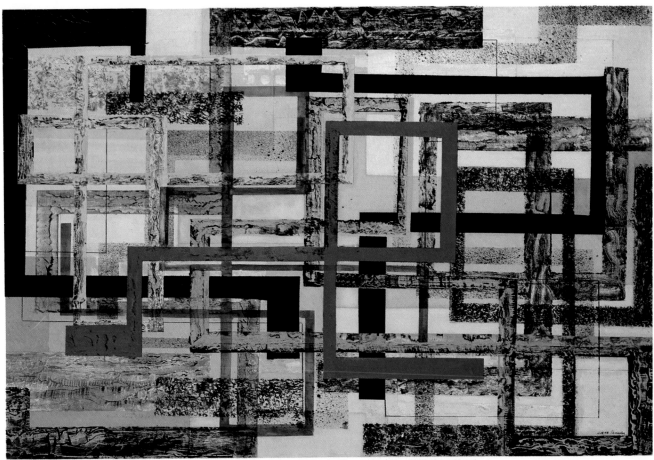

A

I. Rice Pereira, *Daybreak*. Oil on canvas, 60 × 40″ (150 × 100 cm).
The Metropolitan Museum of Art (Gift of Edward J. Gallagher, Jr., 1955). The Edward Joseph Gallagher III Collection).

Some artists are interested in the idea of creating drawings or paintings which have only lines, colors, shapes, textures and patterns. This style of art is called **Nonobjective.**

Most nonobjective artwork is carefully planned. The artist may choose to use a few main colors, shapes or lines. These choices help to unify the artwork.

This painting is unified by the use of many vertical and horizontal lines. The lines create two main kinds of shapes: squares and rectangles. What are the main colors?

Create a nonobjective artwork. Choose a few main colors you like. Decide on the lines and shapes you will draw. Use those colors, lines and shapes to unify your artwork. See if you can create variety and interest, too.

B

Jock Macdonald, *Russian Fantasy*, 1946. Watercolor and ink, 9½ × 13½″ (24 × 34 cm). Art Gallery of Ontario.

This painting is unified by the use of many curved or wavy lines and large irregular shapes. What are the main colors?

The diagonal lines in this artwork create many triangular shapes. What colors help unify the work?

C Jack Tworkov, *Indian Red Series #2*, 1979. Oil on canvas, 72 × 72″ (180 × 180 cm). Courtesy Nancy Hoffman Gallery.

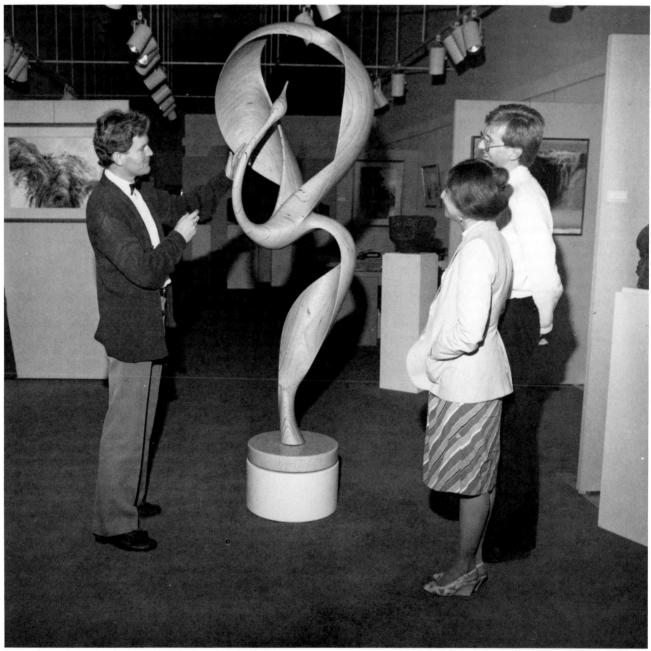

A

Courtesy Louis Newman Galleries, Los Angeles, California

Artists display their best work for others to see. They plan art shows. They frame or mount their best art. They put sculpture or craftswork on stands.

Each work of art has a label. The label tells the name of the artist and title of the artwork. The label also tells what materials were used to create the artwork.

Have you attended art shows? Where do artists in your town have art shows?

120

Learn to mount and label your artwork.

Place your artwork on the background paper. Be sure the borders are even. Lightly trace around the four corners of your artwork.

B

Turn your artwork over. Put paste near the edges. Put paste from corner to corner in an X. Wipe your hands. Paste your artwork down carefully.

C

Use a sheet of paper for the label. Write neatly.

Name: _____

Title of work: _____

Materials: _____

I learned: _____

D

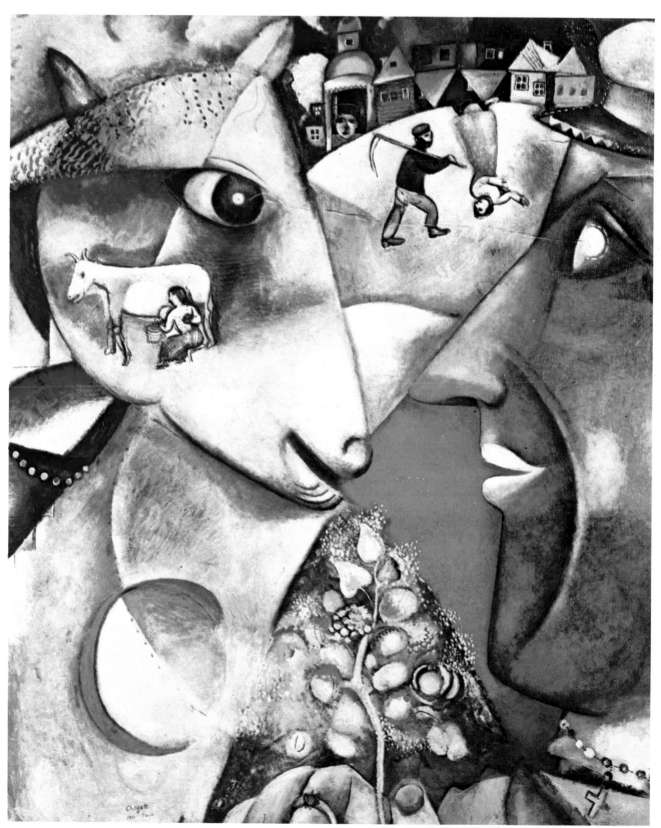

A
122

Marc Chagall, *I and the Village*, 1911. Oil on canvas, 6'3 5/8 × 59 5/8"
(192 × 151 cm). Collection, The Museum of Modern Art, New York (Mrs.
Simon Guggenheim Fund).

Marc Chagall, an artist, created this painting. His painting tells about memories from his childhood in a Russian village.

You can study this painting as art experts might. Here are some things to look for.

Subject matter: What parts of the painting show things the artist might have seen as a child?

Lines: Look for a dotted line between the eye of the donkey and the man. What do you think this line means? What other lines do you see?

Shapes: Imagine why the artist painted some of the smaller shapes inside the larger ones. Why are some shapes upside down?

Colors: Are all the colors realistic? What are the strangest colors?

Textures and patterns: Where has the artist created textures or patterns? Which look invented? Which look real?

Space: Is the feeling of space like that of a real scene? Which parts look very near? Which parts look far away? Why?

Unity: Chagall unified his painting by using four main colors: white, red, blue and green. He also planned the painting so all the large shapes meet near the center.

Do you see a big **X** and a large circle in the painting?

B

You can create a unified drawing about things you remember. Divide the space on your paper into several large shapes. Draw scenes, people or other things you like to remember inside these shapes.

Use a few main colors. Try to repeat some of the lines, colors or shapes.

You can continue to learn about art. Find out about art programs in your community.

A

These children are creating art at a recreation center. Are there places in your community where you can create art? What kinds of art can you create at home?

B

These children are visiting an art museum. They are looking at original works of art, not at reproductions of artwork. Where can you see original works of art? Does your town have outdoor art shows or fairs with artwork? Are there places where you could see artists at work?

C

You can find beautiful things to see in your neighborhood, in stores and in places you may visit this summer. You can even learn about art by watching television. Do you know how?

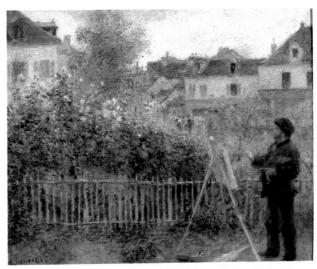

D Auguste Renoir, *Monet Painting in His Garden at Argenteuil.* Wadsworth Atheneum, Hartford, Connecticut.

Sometimes friends get together to create or study art. Auguste Renoir and Claude Monet were friends. They often took art supplies outside to draw or paint. Renoir painted this picture of Monet. Notice what Monet is doing.

You may be interested in a career in art. You can find out about the many art careers by reading books and talking to people who use their art skills. Find out if you can take art classes in every grade until you finish high school. Study various kinds of art. This will help you find out what you enjoy and what you do best.

Glossary

The following art words appear in bold face type within this book. The numbers indicate the first lesson in which the word is used.

Abstraction (ab-STRAK-shen). A style of artwork that does not look real. 46

applique (AP-li-kay). Artwork that is made by sewing pieces of cloth onto a cloth background. 34

arch (arch). A curved or pointed shape in a building; makes an opening in the wall or holds up the roof. 30

artisan (ART-ah-zahn). A person skilled in creating hand-made objects. 24

art museum (art mu-ZE-em). A building where artwork is shown and carefully saved. 60

assemblage sculpture (ah-SEM-blij SKULP-chur). Sculpture made by joining objects or parts of objects together. 55

balance (BAL-ens). Arranged so the parts seem to be equally important or interesting. 21

Baroque (ba-ROHK). The name of an art style that came after the Renaissance. *Baroque* means surprising, unusual. 41.

ceramics (sir-AM-iks). The art of making objects of fired clay. 26

collage (koh-LAUSH). Artwork made by pasting pieces of paper or other materials to a flat surface. 47

color (KOL-er). The way something looks, apart from its size and shape, when light strikes it. A *hue* is a name for a color such as red or blue. 59

column (KOL-um). A large round post used to hold up the roof of a building. 30

contrast (KOHN-trast). Great difference between two things. A light color has contrast with a dark color. 5

cool colors (KOOL KOL-ers). Colors that remind people of cool things. Varieties of blue, green and violet. 8

craftsworker (KRAFTS-wor-ker). A highly skilled person who creates artwork by hand. 24

creative (kre-ATE-iv). Able to make things in a new or different way. 6

design (de-ZIHN). A plan for arranging the parts of an artwork. An artwork which has a planned arrangement of parts. 28

Expressionism (ik-SPRESH-un-ism). A style of artwork in which the main idea is to show a definite mood or feeling. 46

Fantasy art (FANT-a-see art). Artwork that is meant to look unreal, strange or dream-like. 46

fiber artists (FI-ber ART-ists). Artists who use long, thin, thread-like materials to create artwork. 34

formal balance (FORM-all BAL-ens). Artwork that has been planned so one half of it looks very much like the other half. 21

graphic designer (GRAF-ik de-SIHN-er). An artist who plans the lettering and artwork for books, posters and other printed materials. 32

imagination (im-aj-uh-NA-shun). The process of creating a mental picture of something that is unlike things one has seen. 1

Impressionism (im-PRESH-en-ism). A style of art in which the main idea is to show changes in the light, color or action of scenes. 43

informal balance (IN-form-all BAL-ens). Both sides are different but equally important or interesting. 21

intermediate colors (int-er-MEED-ee-at KOL-ers). Colors that are made from a primary and a secondary color (red-orange, yellow-orange and the like). 10

kiln (kill). A special oven or furnace that can be heated to a high temperature. 26

line (line). The path created by a moving point (as one drawn by a pencil point).

logo (LO-go). A visual symbol for a business, club or group. 32

mobile (MO-beel). A sculpture with parts that can be moved, especially by air currents. 52

mosaic (moh-ZAY-ik). Artwork made with small pieces of colored stone, glass or the like. 7

negative spaces (NEG-et-iv spaces). The spaces surrounding a line, shape or form. 52

neutral colors (NEW-trel KOL-ers). In artwork, neutral colors are brown, black, white and gray. 8

Nonobjective (non-ob-JEK-tiv). A style of art in which the main ideas or feelings come from the design created with colors, lines and the like. The artwork does not show objects or scenes. 46

opaque (oh-PAKE). Not possible to see through. 11

pattern (PAT-ern). A choice of lines, colors or shapes, repeated over and over in a planned way. Also, a model or guide for making something. 3

perspective (per-SPEK-tiv). Artwork in which the shapes of objects and distances between them look familiar or "real". 37

portrait (POR-tret). Artwork which shows the face of a real person. 16

primary colors (PRI-mer-ee KOL-ers). Colors from which others can be made: red, yellow and blue. (In light, the primary colors are red, green and blue). 10

proportion (proh-PORE-shen). The size, location or amount of something as compared to that of another (a hand is about the same length as a face). 16

pure colors (pyur KOL-ers). Colors seen in the rainbow or when light passes through a prism: red, orange, yellow, green blue, violet. 8

radial (RAY-di-el). Lines or shapes that spread out from a center point. 24

Realism (RE-ah-liz-em). A style of art that shows objects or scenes as they might look in everyday life. 43

related colors (ri-LATE-ed KOL-ers). Colors that are next to each other on a color wheel. 10

relief sculpture (ri-LEEF SKULP-chur). Sculpture that stands out from a flat background. 13

relief print (re-LEEF print). A print made from a design that stands up from a flat background. 40

Renaissance (REN-ah-sanz). A time in European history (about 1400 - 1600) after the Middle Ages. Artists of the Renaissance discovered many new ways to create artwork. 35

Romantic (row-MANT-ik). A style of artwork in which the main ideas are to show adventures, imaginary events, far-away places or strong feelings. 43

secondary colors (SEK-on-dair-ee KOL-ers). Colors which can be mixed from two primary colors; orange, green, violet. 10

shade (shade). The darkness of colors (as dark or very dark blue). 44

shading (SHAYD-ing). Slight changes in the lightness or darkness of a color or value. 5

shape (shape). The outline, edge or flat surface of a form (as a circle or square). 3

space (space). An empty place or area in which something exists. 59

stitchery (STICH-er-ee). Artwork which is made by using a needle and thread or yarn to create stitches on a cloth. A stitch is one in-and-out movement of a threaded needle. 34

style (stile). An artist's special way of creating art. The style of an artwork helps you to know how it is different from other artworks. 43

subject matter (SUB-jikt MAT-ter). The topic or idea in an artwork, especially anything recognizable such as a landscape or animals. 28

surface design (SUR-face de-ZIHN). A design on the outside or top of something, especially long rolls of fabric, wallpaper and the like. 27

symbol (SIM-bul). Lines, shapes or colors that have a special meaning. A red heart shape is a symbol for love. 33

symmetry (SIM-et-ree). Parts arranged the same way on both sides. 15

tapestry (TAP-e-stree). A heavy woven cloth picture or design, often used as a wall hanging. 25

texture (TEKS-chur). The way an object feels when it is touched. Also, the way an object looks like it feels, such as rough or smooth. 3

three-dimensional (three di-MEN-chen-al). Artwork that can be measured three ways: height, width, depth (or thickness). Artwork which is not flat. 52

tint (tint). A light color. A color mixed with white. 44

traditional symbol (tra-DISH-en-el SIM-bul). A symbol (as the heart shape) that is used in about the same way year after year because it is part of a tradition, custom or belief. 33

transparent (trans-PAR-ent). Possible to see through, such as a clear piece of glass. 11

two-dimensional (two di-MEN-chen-al). Artwork that is flat and is measured in only two ways: height and width. 53

unity (YU-nit-ee). The quality of having all the parts look as if they belong together. 56

value (VAL-yu). The lightness or darkness of a color (pink is a light value of red). 5

variety (va-RI-et-ee). Having different kinds of colors, shapes and the like. 56

warm colors (WARM KOL-ers). Colors that remind people of warm things. Varieties of red, yellow and orange. 8

watercolor paint (WOT-er-kol-er paint). Paint that is mixed with water and looks like a watery ink or dye. 11

weaving (WE-ving). Artwork created by lacing together strands of material (as yarn or thread). 34